IMAGES
of America

MONTGOMERY
COUNTY

IMAGES
of America

MONTGOMERY COUNTY

Michael Dwyer

ARCADIA
PUBLISHING

Copyright © 2006 by Michael Dwyer
ISBN 978-0-7385-4274-4

Published by Arcadia Publishing
Charleston SC, Chicago IL, Portsmouth NH, San Francisco CA

Printed in the United States of America

Library of Congress Catalog Card Number: 2006922695

For all general information contact Arcadia Publishing at:
Telephone 843-853-2070
Fax 843-853-0044
E-mail sales@arcadiapublishing.com
For customer service and orders:
Toll-Free 1-888-313-2665

Visit us on the Internet at www.arcadiapublishing.com

To my family and friends.

CONTENTS

ACKNOWLEDGMENTS

I greatly appreciate the assistance and indulgence of the following people: Dan and Fran Doherty, my coworkers, especially Debbie Malone, Heather Bouslog, Jim Sorensen, Jim Humerick, Lindsey Tschida, the wonderful resources of the Montgomery County Historical Society Library, and the numerous individuals and organizations whom made their photographs available to me.

Thanks also to Bill Offutt, Charles Jacobs, and Joyce Nalewajk for information on Bethesda, the Civil War, and Silver Spring respectively. Special thanks go to Peggy Erickson, director of Heritage Montgomery for alerting me to Arcadia Publishing, and to eternally patient editor, Lauren Bobier.

INTRODUCTION

As a young man, the author experienced the joys of rural Montgomery County while growing up in its post–World War II subdivisions. Saturday morning visits to Sandy Spring with his father were followed by trips with his mother to the old swimming hole at Kemp Mill. Later on he "worked" at Bowie Hill Farm and the old Washington Polo Club, both located on Georgia Avenue at the time.

Undoubtedly these experiences whetted his appetite for more local history. So upon graduation from college he sought employment with the Maryland–National Capital Park and Planning Commission and became the county's first official historian. Almost immediately, he was drafted to conduct a survey of historic resources in Montgomery and Prince George's Counties, as no comprehensive inventory was available.

The survey brought him to areas of the county he did not know existed. He encountered a great diversity of people and places along the way. As he realized the county was changing rapidly, he endeavored to record the passing scene for posterity. The photographs in this book are a result of seeking rare or unpublished images over the years and are supplemented by the author's own photographs taken during the 1970s. Particular emphasis was paid to structures and scenes that were perhaps not the most elegant but rather the ordinary places often overlooked.

Although he sought to include as widespread a geographic distribution as possible, undoubtedly some areas and subjects will not receive extensive coverage (e.g. Rockville, Chevy Chase, and Gaithersburg), as they are well documented in other publications. The author's primary goal was to give the reader a view of the rural roots of the county and celebrate the third century of this heritage, although we are now in fact three counties . . . urban, suburban, and rural. With this in mind, the author's hope is that he can elicit an appreciation for this wonderful county by all who live here.

Michael Dwyer
2006

Special Note: The proceeds of this publication are dedicated to the Friends of the Agricultural History Farm Park in memory of the late Mike Roth and the dedicated volunteers who give so generously of their time.

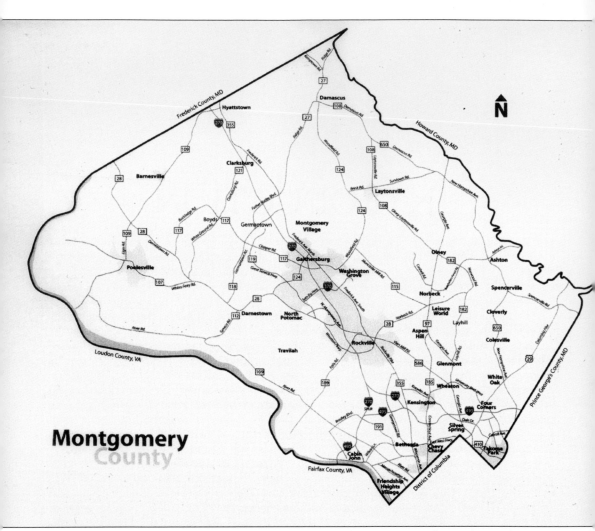

MONTGOMERY COUNTY MAP. Consisting of approximately 500 square miles on the northwestern border of Washington, D.C., Montgomery County is deemed one of the nation's most-favored suburbs. While Maryland Route 355, or Wisconsin Avenue, is the county's historic main street, it is paralleled today by Route I-270, a thriving technology corridor. (Montgomery County, Maryland.)

One

SETTLEMENT AND
DEVELOPMENT

NATURAL FEATURES DEFINE THE COUNTY'S BOUNDARIES. The county was established in 1776 "beginning at the east side of the Mouth of Rock Creek on Potomac River and running with the said River to the Mouth of Monocacy, then with a straight line to Parr's Spring, from thence with lines of the County" along the Patuxent River. (Quote: Maryland Constitutional Convention of 1776. Image: Library of Congress.)

NATIVE AMERICANS WERE THE COUNTY'S FIRST OCCUPANTS. Prehistoric tribes hunted along stream valleys and utilized rock shelters like this one beside Northwest Branch. Along the upper Potomac River, they lived in palisaded villages, but they had moved on by the time the first white settlers arrived in the late 17th century. (Author photograph.)

THE POTOMAC RIVER FROM BLOCKHOUSE POINT. Montgomery County's history is closely linked to this great national waterway. The early explorers and advocates of a Potomac route to the west included Capt. John Smith in 1608, Henry Fleet in 1624, Baron von Graffenreid in 1711, and most especially George Washington, who explored its headwaters and tirelessly promoted navigational improvements. (Author Photograph.)

GEORGETOWN ON POTOMAC AT THE MOUTH OF ROCK CREEK. Once part of Montgomery County, this busy seaport was founded at the head of navigation and was the site of the tobacco inspection warehouse near the terminus of several rolling roads where the crop was wheeled to market in wooden barrels called hogsheads. (Library of Congress.)

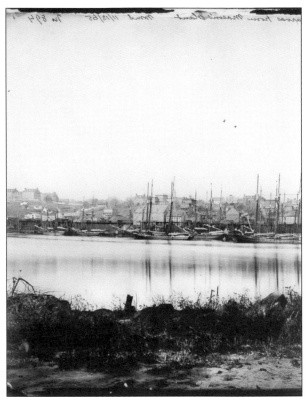

OLD MAGRUDER FARM, BUSSARD FARM, DERWOOD. Scottish settlers like Nathan Magruder moved up from Southern Maryland and established tobacco plantations during the 18th century. The Magruders eventually shifted to growing wheat and grain, at which time the farm was named Waveland. In the 19th century, they were followed by the Bussard family, pictured here with their tenant farmers, the Finneyfrocks. The farm is now the county's Agricultural History Farm Park. (Bussard family photograph.)

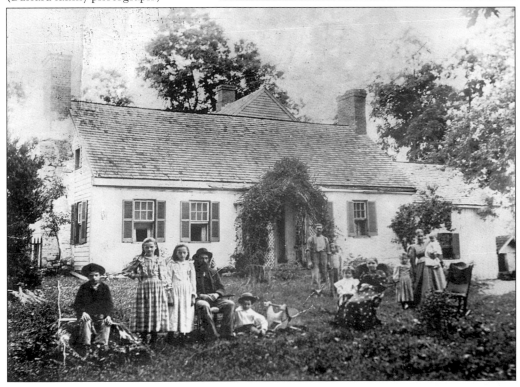

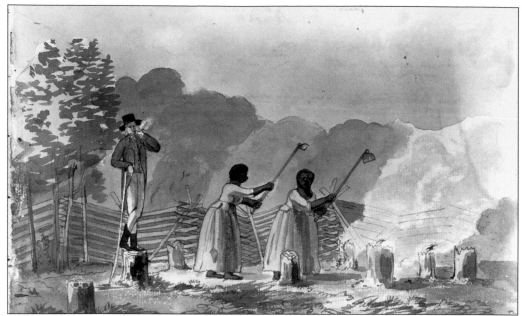

TOBACCO USED SLAVE LABOR. A slave purchased by Nathan Magruder was described as "handy with a hoe and an axe." A traveler passing through the county in the 1790s noted "the fields are overspread with little hillocks for the reception of tobacco plants and the eye is assaulted in every direction with the unpleasant sight of gangs of male and female slaves toiling under the harsh commands of the overseer." (Latrobe Sketch, Maryland Historical Society.)

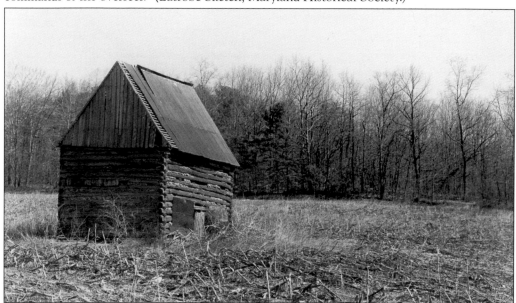

LOG TOBACCO HOUSE, DAMASCUS. Located at Ernest Hilton's farm near King's Valley, these barns (called "houses") were made of chestnut logs and used to cure tobacco leaves. The average size of a tobacco field was only a few acres, as it had to be cultivated with hand labor, but tobacco was grown for years because it produced more income than other crops. Tobacco was literally the "money crop," as it was used as a medium of exchange in the county's early years. (Author photograph.)

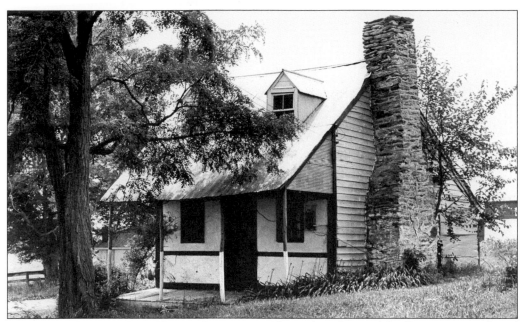

ETCHISON-WARFIELD LOG HOUSE, DAMASCUS. The earliest forms of dwellings were combined with styles from the Tidewater regions and adapted to frontier conditions. In Southern Maryland, the houses were generally built of frame construction, but closer to Pennsylvania, log walls were more common. These structures featured large exterior chimneys to accommodate fireplaces. (MNCPPC photograph.)

UNCLE TOM'S CABIN, OLD GEORGETOWN ROAD. Josiah Henson was a slave on the former Riley Plantation. Harriet Beecher Stowe based her famous anti-slavery book on his memoirs. In the first federal census taken in 1790, fewer than 300 free blacks were recorded as living in the county, and of this number, many lived in Georgetown. The property was recently purchased by the Maryland–National Capital Park and Planning Commission. (Author photograph.)

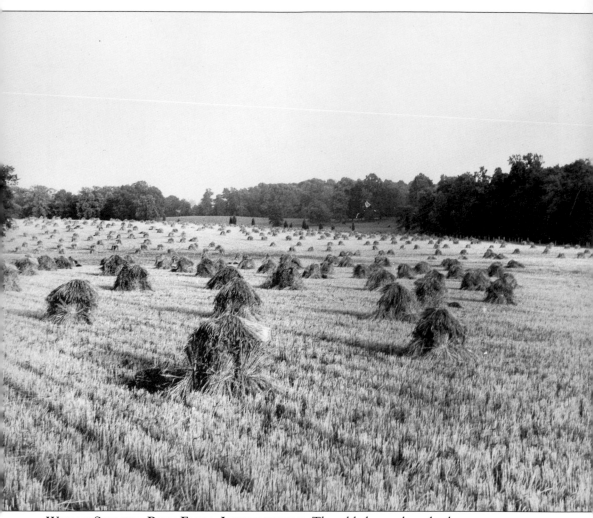

WHEAT SHOCKS, POPE FARM, LAYTONSVILLE. The old slavery-based tobacco economy was eventually replaced by a thriving grain culture. The toll tobacco had taken on the soil, along with price fluctuations, caused farmers to seek a less demanding crop. There was a strong market for wheat, particularly during European wartime, and Baltimore became a busy port based on the export of grain. For many of the county's farmers, the demand came too late, as tobacco had depleted much of the soil by the early 19th century. A steady exodus took place as young families moved west in search of fresh lands in Kentucky and other areas. By 1830, the county was described in the *Diary of George Cooke: 23 Years on a Maryland Plantation 1826–1849* as "miserably poor." The Quakers of Sandy Spring and influential farmers were credited with agricultural improvements that would eventually restore the land. Isaac Briggs of Sharon proposed a national agricultural experiment station to Thomas Jefferson, and Allen Bowie Davis of Greenwood offered his land for a state agricultural college. The U.S. Department of Agriculture and the University of Maryland were ultimately created based on their original ideas. (Pope family photograph.)

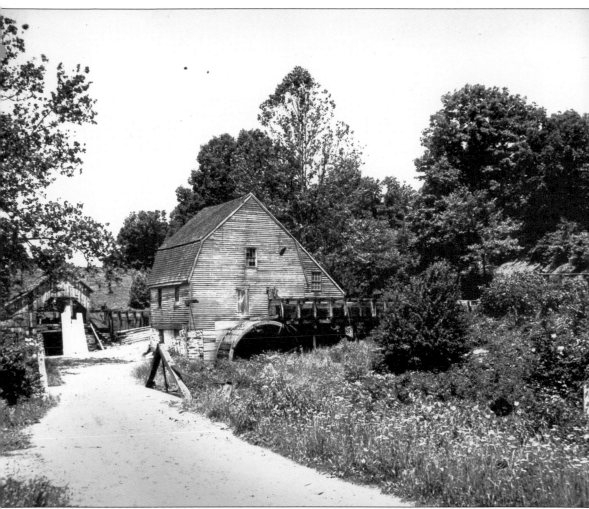

MUNCASTER MILL, NORBECK. In order to process grain and other products, a variety of mills were erected on the county's numerous streams. Gristmills were often accompanied by sawmills, and some, like Muncaster's, also offered wool carding as a laborsaving method that eliminated some of the tedious work done by women. Other milling operations included grinding feed for livestock and animal bones for fertilizer. Mills were present on every sizeable stream in the county and were often owned by businessmen and investors. While mills could be profitable, it was arduous work and the hazards were many. The machinery had to be routinely maintained and repaired, and the threat of fire was constant. Allen Bowie Davis's daughter narrowly escaped injury when her dress caught in the turning waterwheel at Greenwood Mill. Two slaves drowned while dredging a millpond on Cabin John Creek, and one account in a Washington newspaper simply bore the headline "Went in a Man came out a Jelly." (MNCPPC Archives.)

BLACKSMITH SHOP, GERMANTOWN. Transportation of products to market was seriously hindered by primitive road conditions that damaged and slowed wagons and other horse-drawn vehicles. Shown here is the house and blacksmith shop of Oliver C. "Doc" Appleby on Old Germantown Road. The Applebys also owned another shop east of here near Cedar Grove. (Appleby family photograph.)

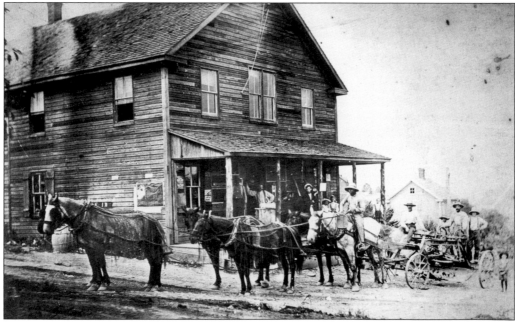

ROAD GRADING CREW AT LEWISDALE STORE. Farmers were required to maintain county roads until the state eventually took over this function. Efforts to improve transportation in the county included forming turnpike companies that charged tolls for use of the road. (Friends of Historic Hyattstown photograph.)

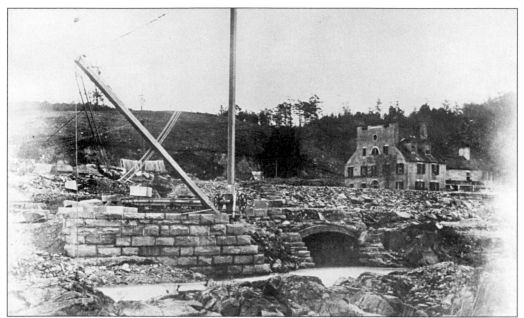

THE CHESAPEAKE AND OHIO CANAL AT GREAT FALLS, C. 1857. The construction of the canal was an effort to skirt the Potomac River, which was largely unnavigable above the fall line. This photograph actually shows the construction of the Washington Aqueduct, which brought water to the nation's capital along today's McArthur Boulevard, which was originally called the Conduit Road. (Library of Congress.)

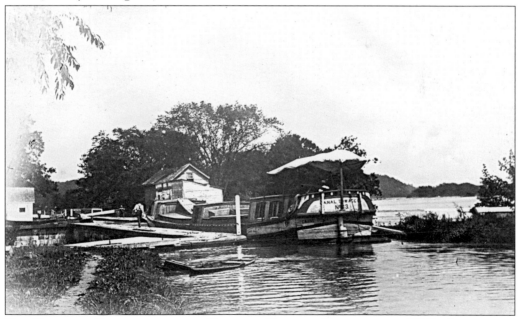

THE CANAL AT SENECA, WITH THE POTOMAC RIVER IN BACKGROUND. While dangerous, it was easier to float heavy cargo, like stone, than to transport over land. Capt. George Pointer, a former slave, recorded a vivid account of the hazards of transporting stone in flat-bottomed boats called bateaux on the river prior to the construction of the canals in Maryland and Virginia. (Thomas Hahn collection.)

SENECA STONE QUARRIES AT SENECA. Along with agriculture and milling, the county's numerous quarries supplied building stone for the nation's new capital. The reddish-brown sandstone had been quarried since the 18th century and was used in a number of farmhouses and outbuildings. Upriver another quarry supplied "Potomac marble" to be used in the hall of statuary at the Capitol Building. (O'Rourke family photograph.)

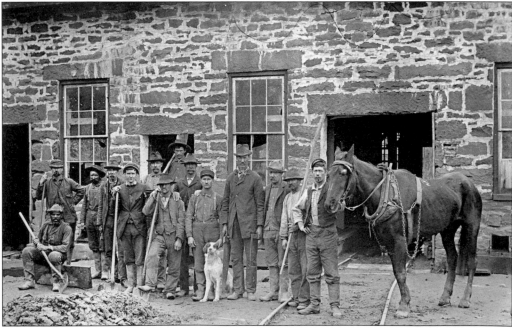

WORKERS AT THE SENECA STONE-CUTTING MILL. Rough stone was quarried and dressed here before being shipped down the canal for use in buildings like the Smithsonian Castle. Despite the lone black worker seated at left, other photographs of the quarry operation document the integral role African Americans played in the county's early industries. (Thomas Hahn collection.)

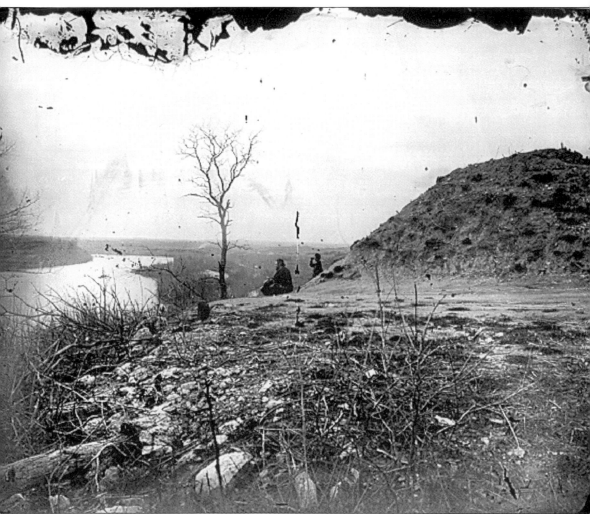

Civil War View of the Potomac River. This view was taken from Battery Alexander, Fort Sumner, Bethesda. This outpost overlooked the canal and river. The outbreak of hostilities caused great alarm about the vulnerability of the nation's capital. In addition to protecting the canal, this fortification was installed to shelter the receiving reservoir, which served as the city's water supply. Farther upriver, there was a large camp located at Muddy Branch and signal stations nearby and at Sugarloaf Mountain. One regimental history described how the hillsides were cleared of timber in order to have a clear view of the valleys below. Beginning at the base of the hill, soldiers with axes would chop halfway through the trees; upon reaching the top of the hill, they would fell the last row of trees, causing an entire forest below to crash. (National Archives.)

WHITE'S FERRY VIEW FROM ANNINGTON. "This County is Noted for Its Secession Proclivities," reported *the Philadelphia Enquirer* in 1861. Montgomery County's location placed it in the middle of the conflict. Hostile territory was not just across the river, it was in fact located within the county, as the Poolesville area in particular was a hot bed of "secesh," or secessionism. Many of the men from this area went south, serving with local units formed by relatives like Elijah Veirs White's Comanches and George W. Chiswell's Exile Band. Col. Edward Baker, a Union officer and close friend of President Lincoln, dined at Annington the night before he was killed at the disastrous battle of Ball's Bluff, which took place near here early in the war. Although slavery was not outlawed in Maryland until 1864, *The New York Times* estimated that more than 8,000 former slaves had been recruited in the state by that date. In one of the many ironic twists of the war, Montgomery County Confederates fought Union troops raised, according to Rachel Means of Waterford, in "that cursed Quaker settlement" Waterford in neighboring Loudoun County, Virginia. (Author photograph.)

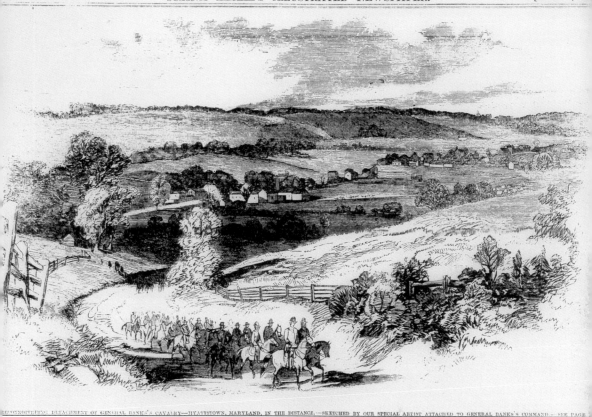

RECONNOITERING DETACHMENT OF GENERAL BANKS'S CAVALRY—HYATTSTOWN, MARYLAND, IN THE DISTANCE.—SKETCHED BY OUR SPECIAL ARTIST ATTACHED TO GENERAL BANKS'S COMMAND.—SEE PAGE

CIVIL WAR VIEW OF HYATTSTOWN FROM LONG HILL. Early in the war, Gen. Nathanial Banks's Union forces were stationed in the county, but they eventually moved on to winter quarters in Frederick. Shown here ascending "Long Hill," looking north toward the village of Hyattstown in the background, one Northern soldier wrote that Rockville "is a dirty looking place to my eye, Hyattstown being much neater in appearance." Troops of both armies marched and camped along the Great Road, including Jeb Stuart in his famous ride and Jubal Early during his raid on Washington following the Battle of Monocacy. "The special correspondent" who accompanied General Banks was artist David Strother, who used the nom de plume of Porte Crayon. His sketches of Montgomery County appeared in *Frank Leslies' Illustrated Magazine* during the war and also in *Harper's Monthly Magazine* in postwar recollections. The area shown to the right is today part of 3,600-acre Little Bennett Regional Park. (Author collection.)

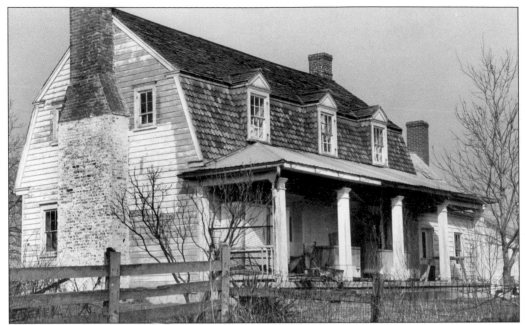

RIGGS HOUSE NEAR LAYTONSVILLE. The old planter class occupying the rich agriculture lands of this vicinity also provided many officers for the Confederate cause, particularly the related Riggs and Griffith families. A number of men from this area joined the daring Mosby's Rangers, including Joshua Riggs, George Robertson, Thomas Landsdale, and Robert Mackall. (Author photograph.)

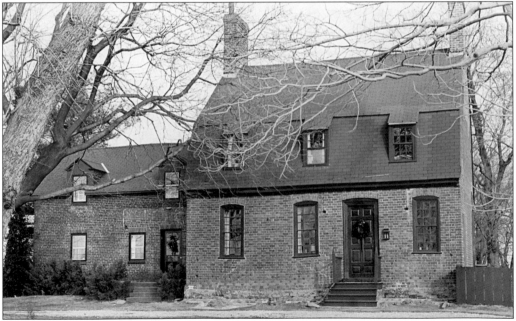

CLIFTON, THOMAS HOME AT ASHTON. The Sandy Spring Quakers or Friends were both opposed to slavery and conscientious objectors. After a raid on the Sandy Spring Store by some of Mosby's men, they formed a posse and ambushed and killed "Wat" Bowie from Prince George's County. The two sides eventually reconciled and served their communities together. (Author photograph.)

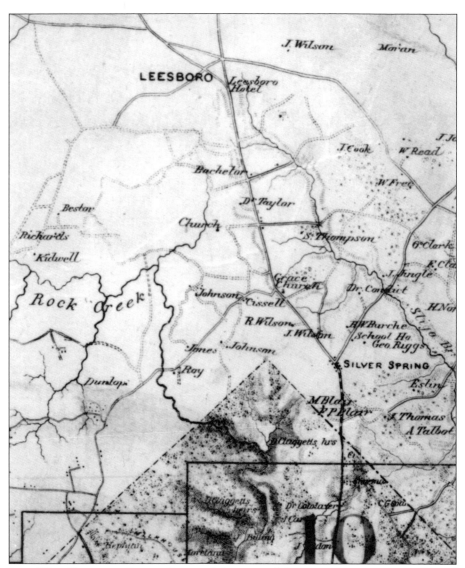

THE CIVIL WAR COMES TO SILVER SPRING. Like many of the county's communities, Silver Spring (then known as Sligo Post Office) was bitterly divided during the war. Those with Southern sympathies were particularly outraged when, in 1862, Union soldiers attempting to steal his pigs killed 71-year-old farmer Thomas N. Wilson. In 1864, following the Battle of Monocacy south of Frederick, Confederate general Jubal Early marched his troops in 90-degree heat down the Seventh Street Road (Georgia Avenue) in a surprise raid on the nation's capital, causing great alarm among the citizens of the county and Washington, D.C. While Thomas Wilson's son John had remained loyal to the Union, John's brother, Richard, who lived opposite him, hosted Confederate general John C. Breckenridge, a former United States vice president. In a note of irony, Union shells struck the outbuildings of John Wilson, but it was his brother, Richard, that sought and received compensation for the damages after the war. The irony continued when 17 Confederate soldiers killed during the siege were buried at Grace Episcopal Church and a new rector was named who had served with Turner Ashby's Confederate cavalry. The Wilsons had always been members of this church, but John Wilson withdrew from the congregation during this period. (Library of Congress.)

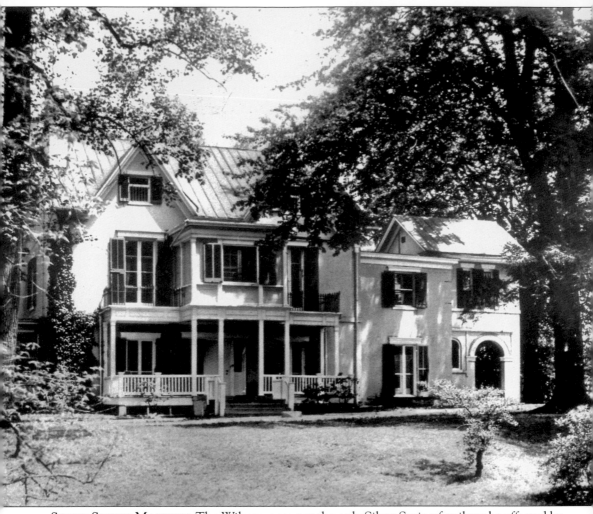

SILVER SPRING MANSION. The Wilsons were not the only Silver Spring family to be affected by the war. Francis Preston Blair's home, Silver Spring, was occupied by General Early, while other troops camped at Montgomery Blair's Falklands and James Blair's Moorings. James Blair was a captain in the U.S. Navy, while relative Samuel P. Lee was a Union admiral. The Lees were related to Robert E. Lee, and Confederate general Breckinridge was relative of the Blairs! Prior to the war, Montgomery Blair had defended slave Dred Scott, while the Montgomery County Agricultural Society had voted to remove Francis B. Blair, his father, because of his Unionist views. As President Lincoln's appointed postmaster general, Montgomery Blair was thought to be the target of Confederate ire when his home, Falklands, was burned to a shell during the invasion. For years after the war, Confederate general Early denied that his men were responsible. (Robert A. Truax.)

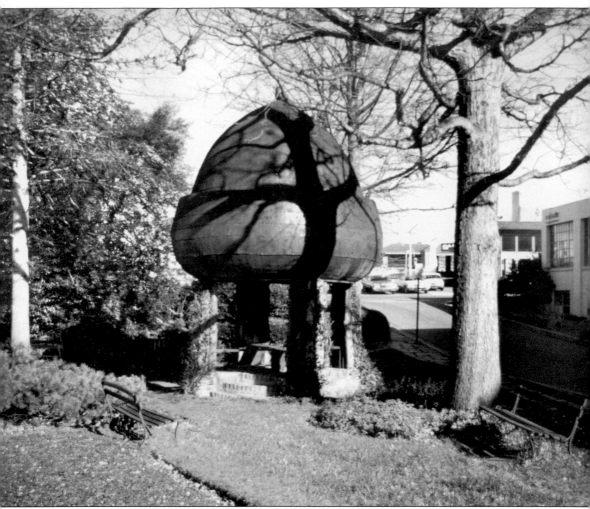

THE SILVER SPRING. One account mentioned that a Confederate soldier was killed by an exploding shell while drinking from the spring in 1864. Eventually the rancor would subside, however, as evidenced by a stone tablet placed at the site of the Silver Spring by Alfred Ray in 1873. Ray was a prominent farmer who resided at Highlands Farm near Kensington and had been imprisoned during the war for his Southern sympathies. The tablet donated from his quarry congratulated the coming of the railroad to Silver Spring and expressed great optimism for the future. The community by now was known as Silver Spring, being named for the spring that also gave its name to the Blair family country home. Their residence in town was the famous Blair House on Pennsylvania Avenue. The gazebo adjacent to the spring dates from the 19th century, as it is in the rustic style so popular in the Victorian era. The spring was dedicated as a public park in the 1950s; it is known more commonly as Acorn Park. (Author photograph.)

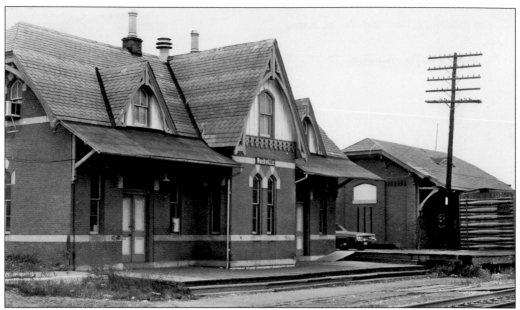

BALTIMORE AND OHIO (B&O) RAILROAD STATION AT ROCKVILLE. The county's seat of government benefited from this railroad and, like other communities along the line, saw a rise in hotels for city dwellers anxious to escape the summer heat of Washington. This fine example of Victorian Gothic architecture was designed by noted architect E. Francis Baldwin and completed in 1873. (Author photograph.)

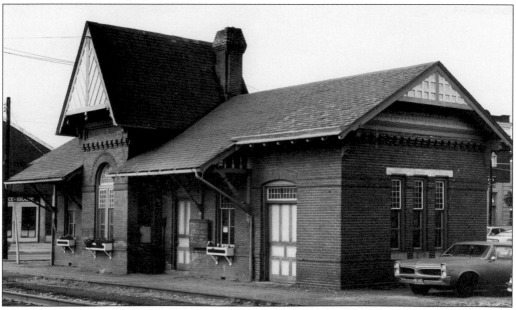

GAITHERSBURG B&O RAILROAD STATION. This village developed into the county's major agricultural depot and milling center as a result of the coming of the railroad. The present structure was built in 1884 as a replacement for an earlier wooden structure. John T. DeSellum of Summit Hall wrote, "this formerly humble village set in the center of our County has since the completion of the railroad developed a trade and importance hitherto thought impossible." (Author photograph.)

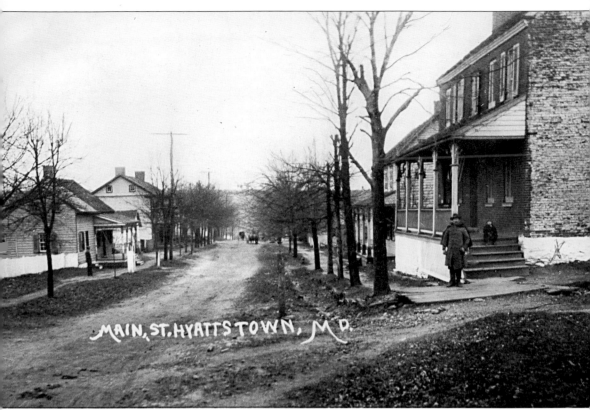

HYATTSTOWN ON THE GREAT ROAD. Although Rockville and Gaithersburg were located on the county's main street, towns bypassed by the railroad missed out on the economic benefits. The road was great in name only, as it remained a quagmire in winter and a dustbowl in summer. In the 1830s, the section of road between Rockville and Frederick was called "the deficient link of the Great National Western Road" by the *Frederick-Town Herald*. Even earlier, the road had been one of the impediments to General Braddock's ill-fated march during the French and Indian War. The Revolutionary War further exposed the inadequate transportation system in the young country. In 1774, the state appropriated funds to improve what the Acts of the Assembly, 1774, chapter xxi called "the road from Frederick-Town leading by Dowdens to George-Town." Even the reported overnight visits by Presidents Andrew Jackson and James Polk could not remedy the condition of the road. The road was the focus in the 1890s of Coxey's Army, a group of unemployed men who marched on Washington in order to create public works projects like road improvements. They camped out on the banks of Little Bennett Creek amid much fanfare from the press. (Friends of Historic Hyattstown photograph.)

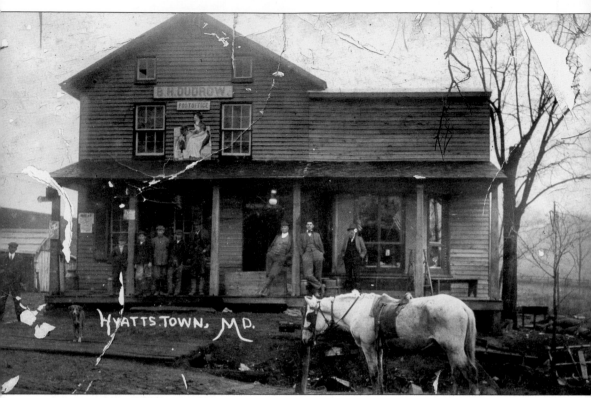

DUDROW'S STORE AT HYATTSTOWN. The Great Road was also known as Frederick Road or Route 355. The highway would remain unpaved until 1920, when grateful citizens held a celebration at nearby Mountain View Park. One of the unforeseen results of the improvements was that up-county residents could now go to Frederick by automobile, bypassing the local country stores. Some enterprising residents, like the Burdettes, simply shifted gears from harness making to a car dealership in the lower end of town, where wagoners had stopped in earlier times. Prior to its destruction by fire, the store was the subject of a Department of Agriculture film depicting a typical cracker barrel economy. The advertisement seen on the front of the store was for Singer sewing machines, which were sold in Hyattstown by Levi Ziegler. Like Bradley Dudrow, the Zieglers had owned and operated the Hyattstown Mill at one time. The mill and miller's house remain in adjacent Little Bennett Regional Park. (Friends of Historic Hyattstown photograph.)

Two

BEGINNINGS OF SUBURBIA

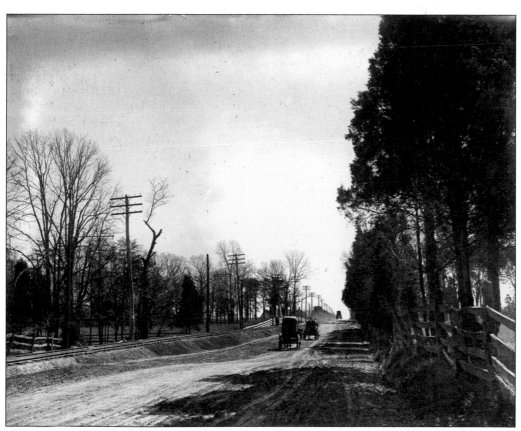

GEORGIA AVENUE NEAR SILVER SPRING. The trolley car tracks seen at left in this photograph were a harbinger of change for the old horse-and-buggy mode of transportation. Variously known as the Seventh Street Road, the Brookeville and Washington Turnpike, and even the Union Turnpike for the company that maintained it, the road extended as far north as Westminster, near the Pennsylvania border. (Library of Congress.)

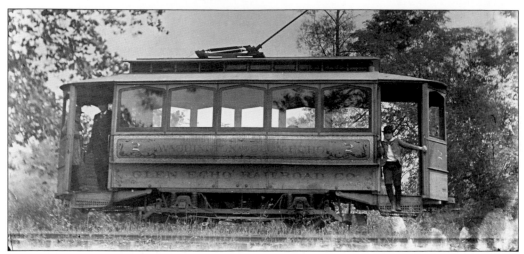

GLEN ECHO RAILROAD TROLLEY CAR. This was one of several lines extended into the county near the end of the 19th century. City workers could now commute to suburban homes, leading to a building boom of close-in communities. This line also extended to the speculative "Glen Echo on the Potomac," where the draw was a Chautauqua that later became a popular amusement park. (Reynolds family photograph.)

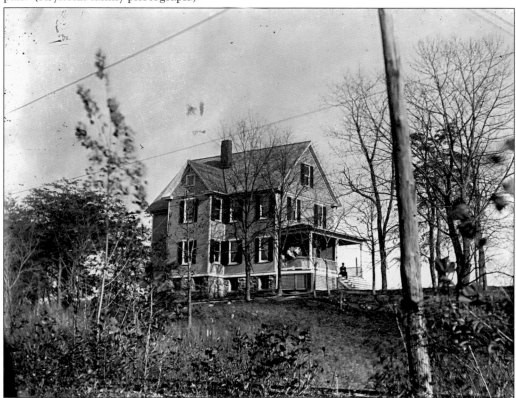

REYNOLDS HOME AT FRIENDSHIP HEIGHTS. The Victorians were convinced that urban living caused insanity and were anxious to escape to the countryside. With no air conditioning and inadequate sanitation in the city, they sought the wooded high ground in Montgomery County. The trolley tracks can still be detected at Willard Avenue Park. (Reynolds family photograph.)

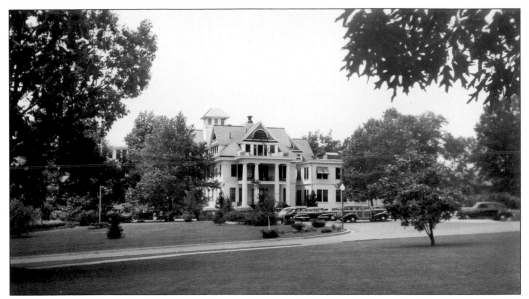

TAKOMA PARK LED THE WAY. This community featured many of the modern amenities needed by the new suburbanites. The sanitarium built by the Seventh Day Adventists in 1907 was the first modern medical facility to serve county residents outside of the District. (MNCPPC Archives.)

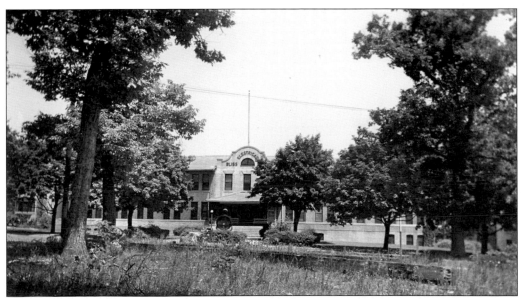

BLISS ELECTRICAL SCHOOL, TAKOMA PARK. Constructed on the site of a grand Victorian hotel that burned in 1908, this was one of several schools begun in Takoma Park. Sometimes referred to as "the Alamo" for its unusual architecture, this campus became the site of Montgomery College, the first community college in Maryland, which now includes branches at Rockville and Germantown. (MNCPPC Archives.)

ROBERT B. MORSE FILTRATION PLANT AT BURNT MILLS. The county's streams were becoming health hazards as a result of new development, so the Washington Suburban Sanitary Commission (WSSC) was created in 1918. Up until that point, sanitation was left up to individual homeowners or a hodgepodge of towns and villages. Typhoid epidemics killed hundreds of people in the state each year, and the situation was deemed urgent. This was ironic because residents had moved to the suburbs were in part trying to avoid "the vapors" and other unpleasant aspects of the city. Robert B. Morse became the WSSC's first engineer and went to work as complaints from the Montgomery County Grand Jury, the District, and even Congress began to mount. The commission began to acquire private treatment systems that had been constructed in Chevy Chase, Edgmoor, Kensington, and Takoma Park. In 1924, the filtration plant was begun using a second-hand facility from Hopewell, Virginia. It served until 1936, when a new plant, "the first of its kind in the world," according to the *History of the WSSC, 75th Anniversary 1918–1993*, was constructed along Route 29. (Montgomery County Historical Society photograph.)

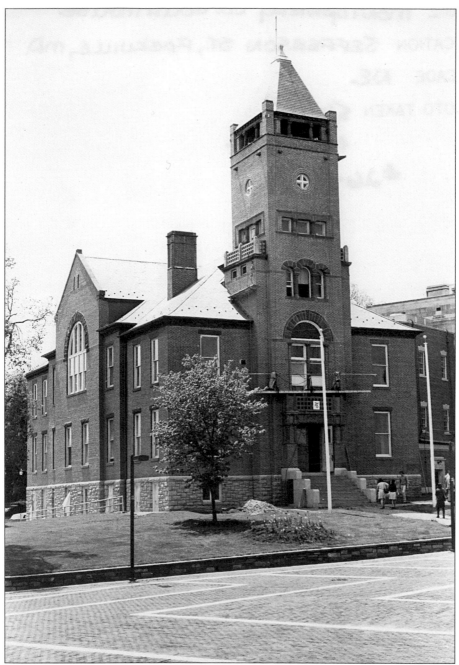

ROCKVILLE COURT HOUSE. The old county government structure was not equipped to serve the growing demands of the new arrivals down-county. Centered around the sleepy county seat at Rockville, it was dominated by the old guard consisting of lawyers, farmers, and small businessmen. The latter had an aversion to taxes, while the newcomers consistently pushed for more services. This source of tension was eventually resolved through the use of bond issues and special user fees for the down-county. Ironically the suburban residents' concerns were championed by members of the area's oldest families. T. Howard Duckett oversaw the creation of the WSSC, and E. Brooke Lee ushered in the Park and Planning Commission a decade later. (Author photograph.)

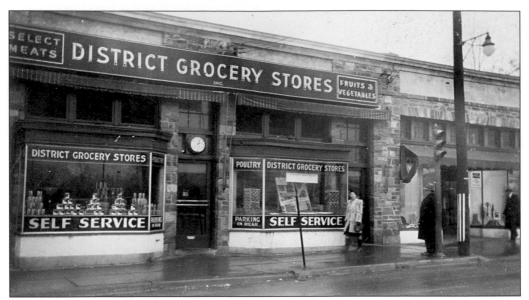

"DGS" at Wisconsin Avenue, Bethesda. At first, the new arrivals depended heavily on the District for all but the most basic shopping needs. Rockville had a DGS (District Grocery Store) in addition to a Piggly Wiggly store more representative of a Southern village. The statue of a Confederate soldier occupying a place of prominence in front of the courthouse was in contrast to Bethesda's *Madonna of the Trail* statue, which honored pioneer women. (MNCPPC Archives.)

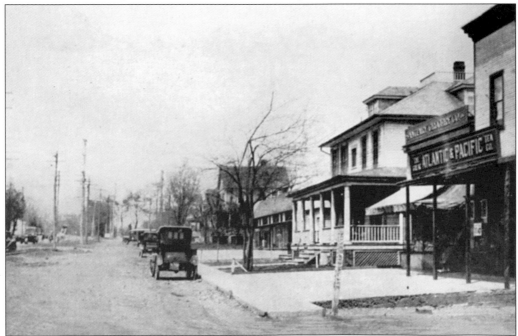

A&P at Georgia and Silver Spring. Silver Spring did not have any sizable population until after World War I, but between 1920 and 1930, the county grew by more than 40 percent, and the business community took note. Col. E. Brooke Lee and Capt. Frank Hewitt had served together in World War I and became involved in community affairs and development upon their return. (Leet Melbrook photograph.)

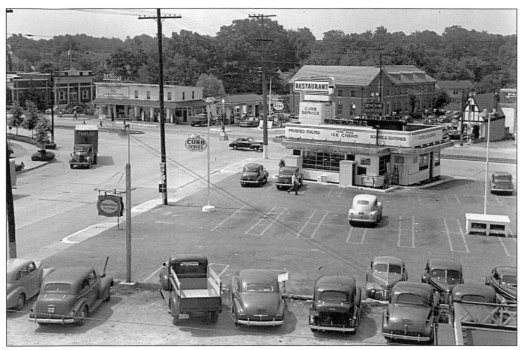

SILVER SPRING AT GEORGIA AVENUE AND COLESVILLE ROAD. Shown from left to right are the County Office Building, several service stations, a drive-through White Tower Restaurant, and the Walsh Motor Company. The impact of the automobile was clearly a growing factor, as evidenced by this photograph. Silver Spring's old rural flavor was disappearing as newer, more modern businesses replaced the old country stores. (MNCPPC Archives.)

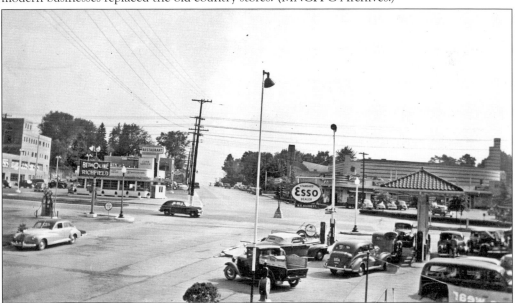

GEORGIA AVENUE AT COLESVILLE LOOKING NORTH. As indicated by the wide-open highways shown here, the automobile gave increasing numbers of residents new mobility. The establishment of agencies like the Johns Hopkins Applied Physics Lab, visible at left, indicated recognition that the suburbs were here to stay and that not all the jobs were downtown. (MNCPPC Archives.)

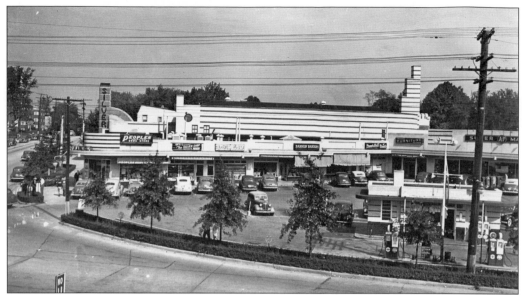

ART DECO SILVER SPRING SHOPPING CENTER. The streamlined architecture of this shopping center and the Silver Spring Theatre underscored how up-to-date the new residents' tastes were. Nearby Kensington featured a very avant-garde junior high school in the moderne style, and even up-county Damascus would acquire the deco Druid Theatre, named after the original owner, Druid Clodfelter. (MNCPPC Archives.)

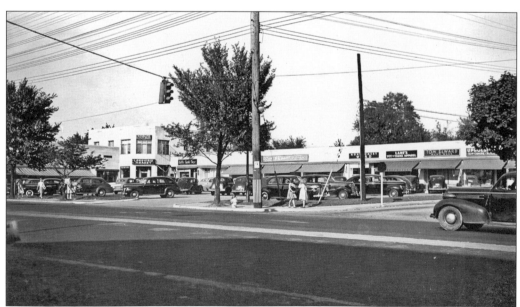

LAKE VIEW MARKET, WISCONSIN AND LELAND, BETHESDA. The "park and shop" concept was pioneered by Washington real-estate firm Shannon and Luchs. The mention of a non-existent lake was explained by the son of the original developer, who recalled that his father had to pump huge amounts of water from the site's deep excavation. (MNCPPC Archives.)

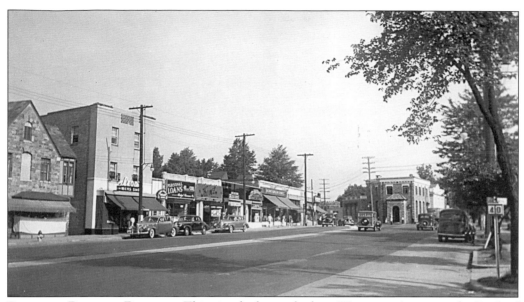

BETHESDA BUSINESS DISTRICT. This view looks north along Wisconsin Avenue to the Bank of Bethesda, where a blacksmith shop had formerly stood. Situated along the old trail west, the area was simply known as Darcy's Store and Post Office. With the development of adjacent Chevy Chase however, the community would become one of the county's primary commercial centers. (MNCPPC Archives.)

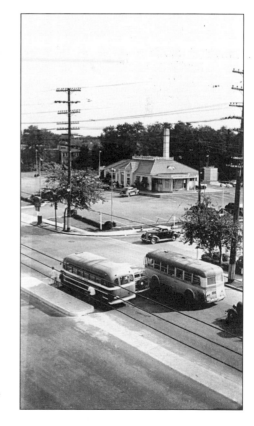

HOT SHOPPES AT WISCONSIN AVENUE AND EAST-WEST HIGHWAY. Originally there was no direct link between Bethesda and Silver Spring. People wanting to travel between the two areas had to go into the District and double back. The winding East-West Highway, constructed in 1928, quickly became the county's busiest thoroughfare. (MNCPPC Archives.)

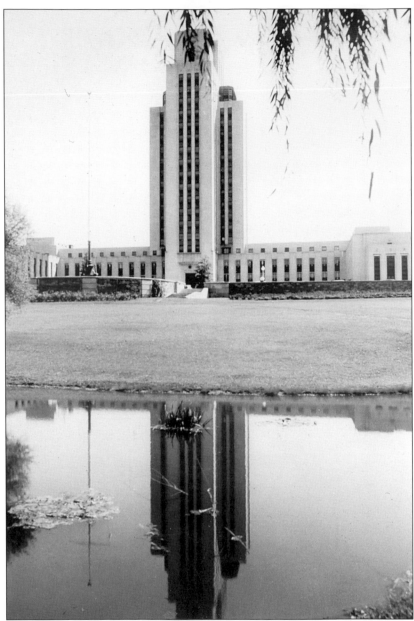

BETHESDA NAVAL HOSPITAL. In the early 20th century, Rockville Pike was lined with handsome estates, including the Peter and Wilson properties. About the time of the Depression and World War II, Luke Wilson approached Pres. Franklin D. Roosevelt about donating his property for some public purpose. Roosevelt was delighted because he wanted to disperse federal agencies that were concentrated and crowded in Washington. Eventually the Wilson and Peter properties grew into the National Institutes of Health. Across the pike, the old Bohrer Farm became equally famous as the Bethesda Naval Hospital. President Roosevelt reportedly sketched the design for the hospital on an envelope (although it appears to bear a marked resemblance to the Nebraska State Capitol). The name Bethesda came from the old Presbyterian church on Rockville Pike. A biblical reference, it means a place of healing, appropriate for both the Naval Hospital and the National Institutes of Health. (Montgomery County Historical Society.)

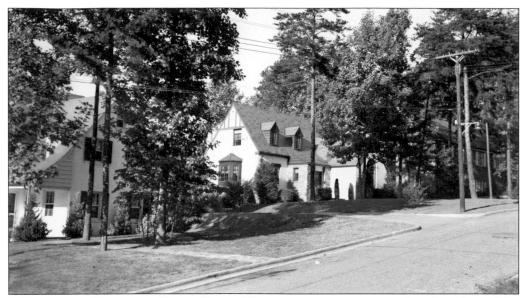

ROLLINGWOOD HOUSES AT CHEVY CHASE. The county commissioners and residents favored the upscale, single-family type of residences. It was a point of pride that the county had managed to avoid the less desirable forms of development that had sullied other communities. For example, the proliferation of package stores was prevented when the county took control of liquor sales and distribution following the end of Prohibition. (MNCPPC Archives.)

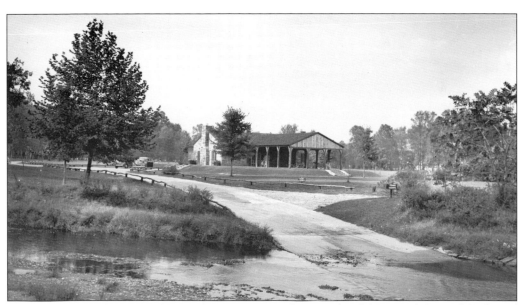

MEADOWBROOK SHELTER, ROCK CREEK PARK. The Maryland–National Capital Park and Planning Commission was created in 1927 to provide for orderly development and parkways in the Maryland suburbs. Congress had protected the Rock Creek Steam Valley in the District, but no safeguards existed for its origins in the county. The commission was created by the state legislature, and plans for the park were announced in 1929 in E. Brooke Lee's *Maryland News.* (MNCPPC Archives.)

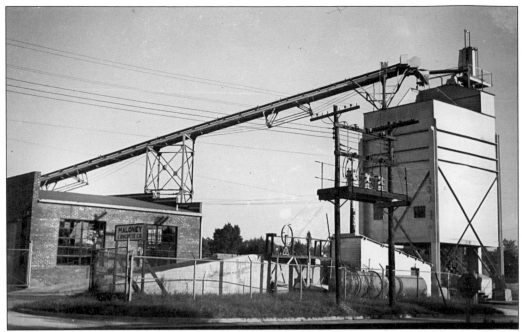

MALONEY'S CONCRETE PLANT, ARLINGTON ROAD, BETHESDA. Industry was kept to a minimum, making allowances for those businesses necessary to foster growth and development. The federal government and the building and real-estate industry employed many down-county, while agriculture was still a strong force north of Rockville. (MNCPPC Archives.)

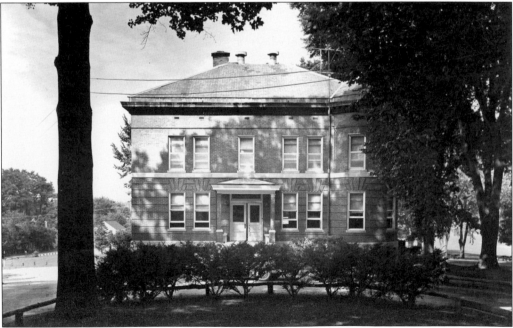

BUREAU OF ANIMAL INDUSTRY STATION, BETHESDA. When the noxious odors and sounds of the U.S. Department of Agriculture facility clashed with new residential development, citizens had it closed and turned into Bethesda–Chevy Chase Norwood Recreation Center. (MNCPPC Archives.)

JESUP BLAIR PARK, SILVER SPRING. On the eastern side of the county, Violet Janin Blair donated land for a park in the name of her brother in the 1930s. The new park, located at the District line, featured tennis courts and picnic areas and proved quite popular with residents. (MNCPPC Archives.)

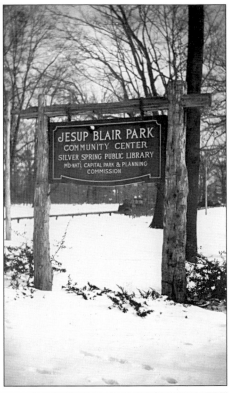

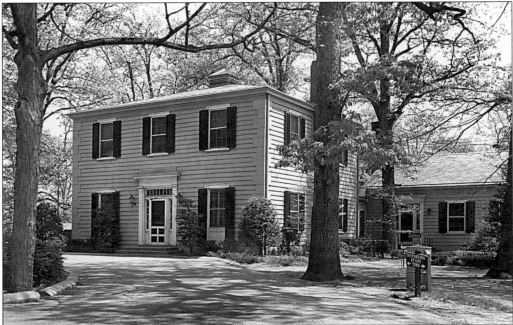

THE MOORINGS IN JESUP BLAIR PARK. Included in the gift was the old summer home of Capt. James Blair, U.S. Navy, which was built in the 1850s. James Blair was Violet Blair's father. Soon after it was acquired, the house was remodeled in the Colonial style and became the county's first permanent public library. (MNCPPC Archives.)

NORTH SLIGO PARK HILLS AT COLESVILLE ROAD. The county's position as the most favored suburb of Washington was based on the emphasis on single-family housing adjacent to a system of parks and parkways. As long as the tax rate stayed low and property values stayed high, the civic associations were happy. (MNCPPC Archives.)

FALKLAND APARTMENTS IN SILVER SPRING. The rapid growth of wartime Washington resulted in a flood of new residents who needed to be housed according to their modest government incomes. As families doubled up and some residents took in boarders, pressure for apartment construction grew, threatening the "country club" lifestyle the citizens had grown accustomed to. (MNCPPC Archives.)

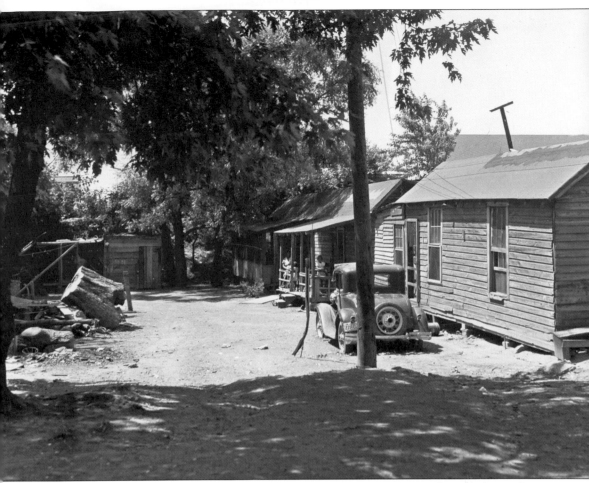

"Colored" Housing in Downtown Bethesda. African American residents had even fewer choices for housing, as deed restrictions often excluded them from all but a few enclaves. Actually the black population of the county declined steadily, dropping from 40 percent in 1880 to 4 percent by 1960. As the county had been predominately rural, most blacks were historically employed as farm laborers or domestics. Better opportunities had drawn many to the city, but there were few housing options in between. When the suburbs began to sprout housing developments, they did not include black citizens until the Great Society programs of the 1960s. Of all the forms of racial discrimination, housing was the most glaring, according to author Richard K. MacMaster. (MNCPPC Archives.)

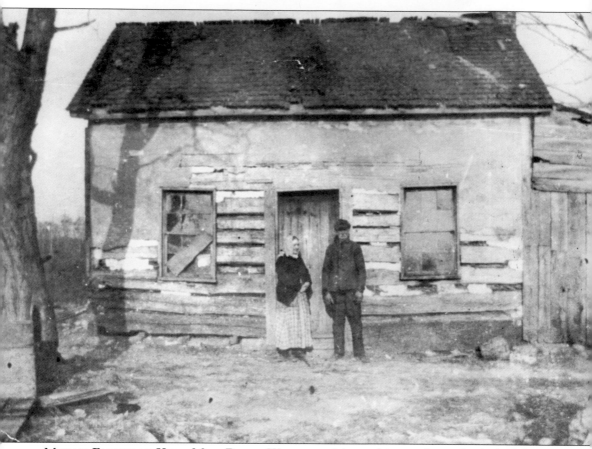

MORAN FAMILY AT KEMP MILL ROAD, WHEATON. Many white residents also lacked decent housing in the Depression, as this photograph attests. The county had operated an almshouse or poor farm at Rockville for the most indigent, but it proved inadequate by the 1930s. Pres. Franklin D. Roosevelt's New Deal programs were enacted to keep the elderly and poor from suffering. While the county often was one of the country's first recipients due to its proximity to Washington, many residents continued to live in primitive conditions. The winter was particularly hard for these residents, and the County Social Service League announced in 1932 that it was unable to assist half of those requesting help due to a lack of funds. Numerous recollections of black and white residents living in the rural up-county usually claimed they suffered less hardship, as they always had plenty to eat. One schoolteacher in the county told of bringing a loaf of white bread to her poor students, who "thought it was cake." (Gray family photograph.)

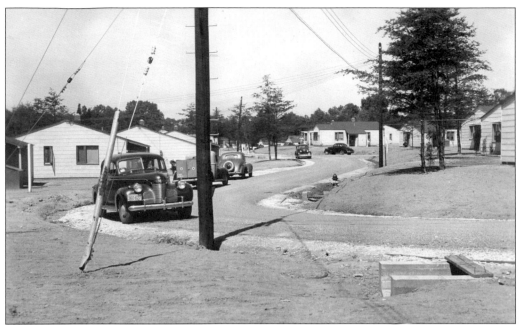

GOVERNMENT HOUSING AT CABIN JOHN. The need to house the growing federal workforce during World War II resulted in the construction of modest dwellings like those built for workers at the David Taylor Model Basin. The war had halted housing construction, so the government intervened, having created programs like the Federal Housing Authority (FHA) in the preceding years. (MNCPPC Archives.)

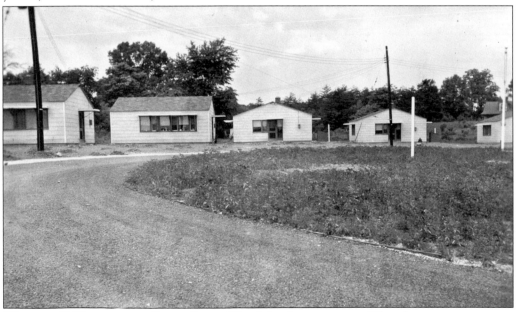

"COLORED" HOUSING AT CABIN JOHN. The federal government did make some attempts to provide similar but segregated buildings for African Americans. Located on Carver Road, these housing units were provided for black residents during the same time period. As prices of close-in real estate have soared in recent years, these properties have been sought for "tear-downs" and "build-ups." (MNCPPC Archives.)

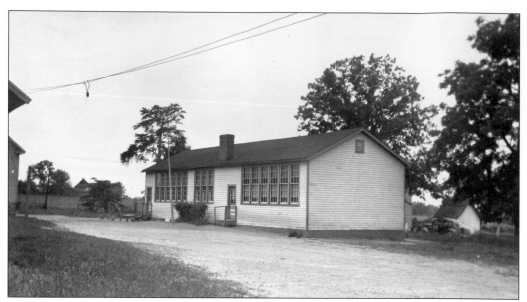

NORBECK SCHOOL ON MUNCASTER MILL ROAD. Built in 1927, Norbeck ceased to operate as a school at the end of segregation. Like a number of obsolete schools, it was turned over to the Maryland–National Capital Park and Planning Commission for use as a community recreation center. (Author photograph.)

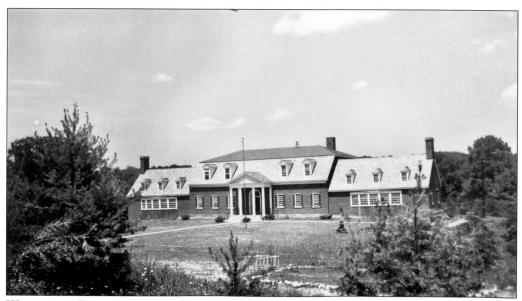

WESTBROOK ELEMENTARY SCHOOL, BETHESDA. The down-county residents demanded the best for their children. In 1945, *The Bethesda Record* claimed "the richest County in Maryland should have the best schools in the country." (MNCPPC Archives.)

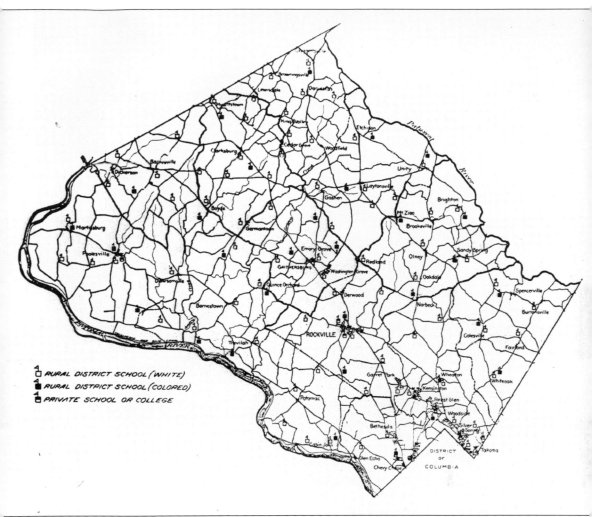

1912 Map of County Schools. "Separate but Equal" was the norm for county schools, which in fact meant that there was a great disparity. Like most Southern states, public education was largely nonexistent prior to the Civil War. Schooling was limited to the upper classes who could afford tutors or attend private academies. Following the *Brown v. Board of Education* decision in the 1950s, the county finally began to integrate. While rural schools remained primitive down-county, schools in affluent areas were up-to-date facilities. A 1929 issue of *the Maryland News* that featured pictures of the all the county's elementary schools shows that most up-county facilities were still simple one-room structures. (Rural Survey of Maryland.)

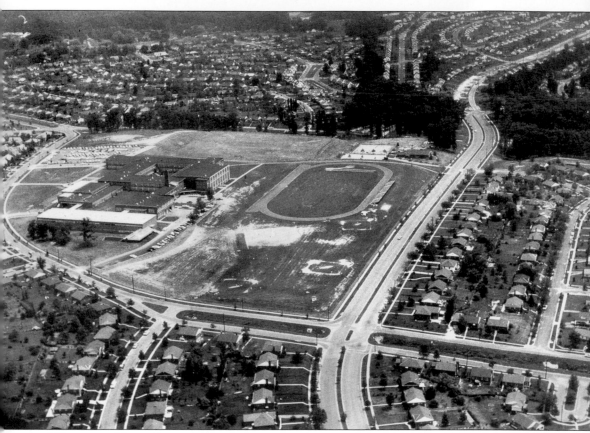

WHEATON HIGH SCHOOL. By the time development began in earnest, the area had been established as home to a number of families who wanted a rural lifestyle while commuting to jobs in the city. The rural flavor of the area was altered drastically, however, as the population doubled between 1946 and 1950 and doubled again between 1950 and 1960. In the 1960s, the former Stubbs farm known as Avon or Shawfields was purchased as the nucleus of the County's first regional park. *The Montgomery County Sentinel* called Wheaton Regional Park "an oasis of green in a sea of asphalt." The pace of development was beginning to alarm some county citizens, including Rachel Carson, who lived adjacent Northwest Branch Park. It was here she was inspired to write her famous "Silent Spring," which became the nation's environmental wake-up call. As a result of her writings, a conservation park north of Brookeville has been named in her honor. (Montgomery County Historical Society photograph.)

Three

EARLY HOUSING STYLES

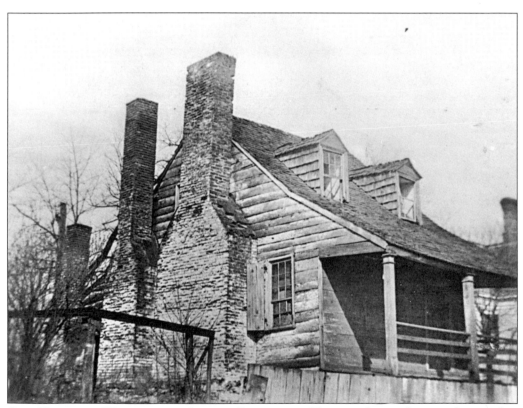

OLD HOUSE ON WASHINGTON STREET, ROCKVILLE. Photographic evidence indicates that examples of the old Tidewater style of dwelling persisted long after more fashionable styles had taken their place in the county. In the words of one resident, some families were living in the 18th century during the 19th century. This picture gives a hint of what Rockville (known earlier as Montgomery Court House or Williamsburg) must have looked like during the 18th century. (Montgomery County Historical Society photograph.)

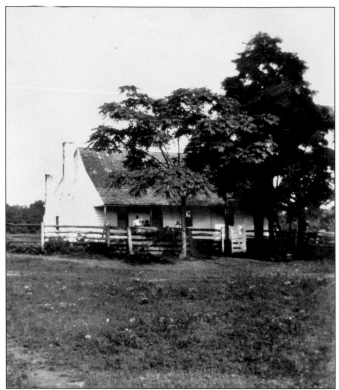

The William Dennis Poole house, shown in the photograph *c.* 1900 was typical of a much earlier house style. The farm was heavily occupied by Union troops during the Civil War: earthworks were dug and the house was occupied as a smallpox hospital. After William Dennis Poole's death in 1869, his heirs filed a claim with the United States for the loss of use reporting that "quite a battle had taken place on the farm" with Confederates led by Col. Elijah Veirs White, who was born at nearby Stoney Castle Farm. About 1870, the present-day Victorian house was built and the old house occupied by tenants until it was removed some time after 1914. (Montgomery County Historical Society photograph.)

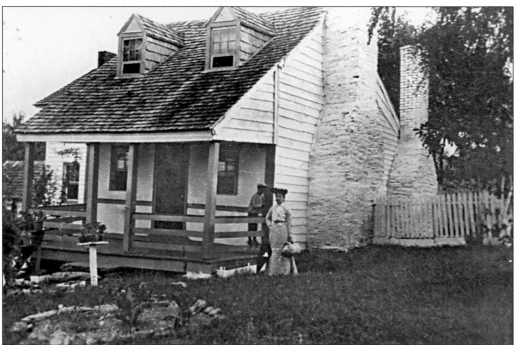

ETCHISON-WARFIELD LOG HOUSE, DAMASCUS. This house type had probably been widespread but has now disappeared entirely. A later photograph of this house appears on page 13. (Janie Woodfield Payne photograph.)

MOUNT PLEASANT, WHITE'S FERRY ROAD, POOLESVILLE. Examples of the small primitive dwellings that dominated the county in the 18th century are rare today. This was the home of Alexander Whitaker, who had his lands resurveyed in 1797 as Mount Pleasant. By the Civil War, it had became the home of the Cecil family, who were reimbursed by the county for damages caused by Union troops after the Cecils' claim was rejected by the federal government. (Author photograph.)

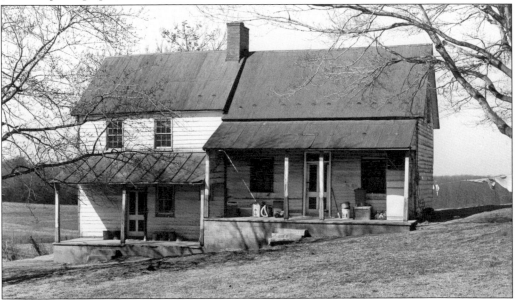

OLD BURDETTE FARMHOUSE, PURDUM ROAD, DAMASCUS. This small, simple residence was of log construction but has, like so many of the county's old home, burned since this photograph. This house resembles a similar structure, the Capt. Peter Boyer house that formerly stood at nearby Mendelssohn Terrace Farm. (Author photograph.)

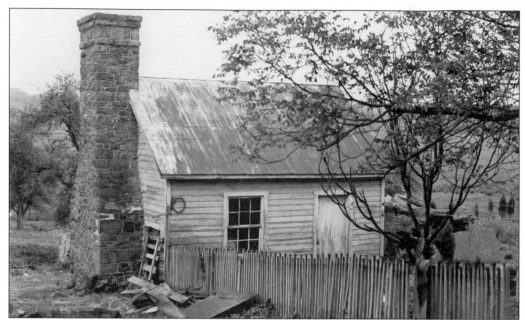

OUTBUILDING AT THE WHITE-CARLIN FARM, BUCKLODGE. Often mistaken for slaves' quarters, this was probably used for a summer kitchen. These structures were in fact sometimes where household servants would reside in order to be at the beck and call of their owners. This property includes a large sandstone Georgian house and one of the largest barns in the county, both recently restored. (Author photograph.)

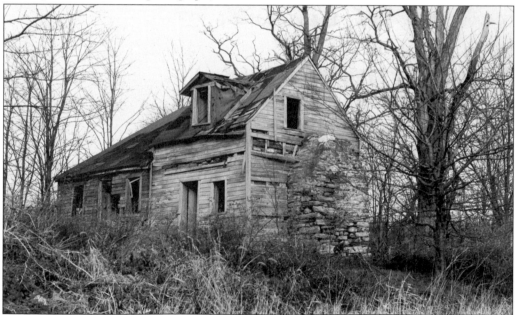

LOG TENANT HOUSE, MILESTONE DEVELOPMENT, GERMANTOWN. While the most primitive of these houses have disappeared by now, the more-livable, larger homes have often been preserved, such as the adjacent Water's House operated by the Montgomery County Historical Society in cooperation with the Maryland–National Capital Park and Planning Commission. (Author photograph.)

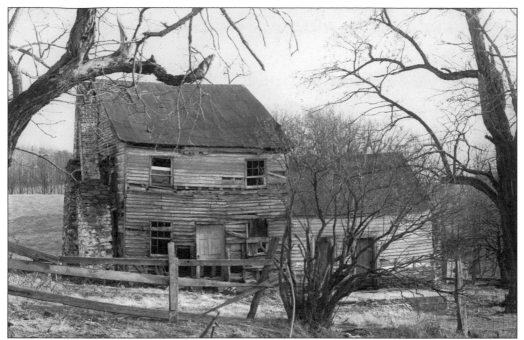

OLD LEWIS HOUSE, LEWISDALE. Some dwellings were two stories in height with double-end chimneys and featured one-story kitchen wings. The majority of such houses were designed by builders or carpenters rather than architects. The resulting styles sometimes made for unique structures, especially when families opted to add on instead of building new. (Author photograph.)

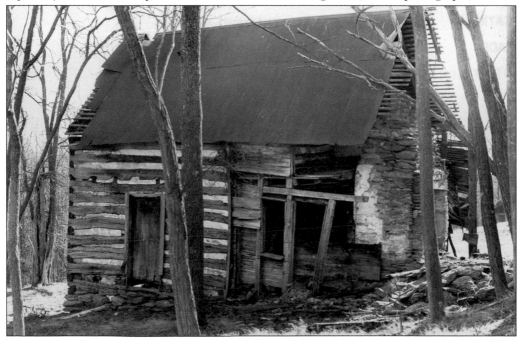

J. N. SOPER LOGHOUSE, HYATTSTOWN. While a number of these structures existed until the mid-20th century, rising standards of living and housing code enforcement have largely eradicated them. Time and termites have accelerated the pace of their demise. (Author photograph.)

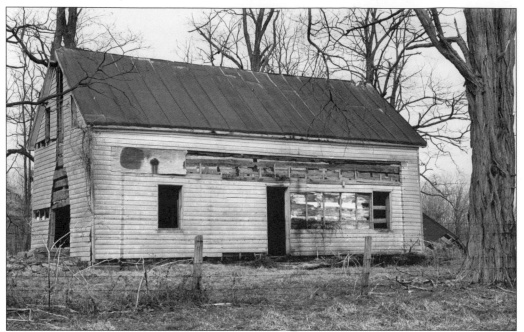

GLAZE LOGHOUSE, GLADHILL FARM, DAMASCUS. The exterior log walls were protected from the elements by siding or weatherboards. Tobacco is still grown on the Glaze family farm nearby. The Gladhill family came from Frederick County and operated a mill at Browningsville; today the family operates the county's John Deere dealership. (Author photograph.)

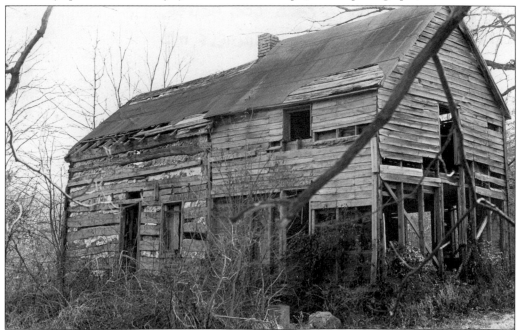

LOG HOUSE AT MURPHY'S FORD, BURTONSVILLE. Often the original log section was retained while a new frame section was added. Located at one of the long-forgotten fords that used to cross the Patuxent River into Howard County, this area now backs up to the reservoir for the county's drinking water supply. (Author photograph.)

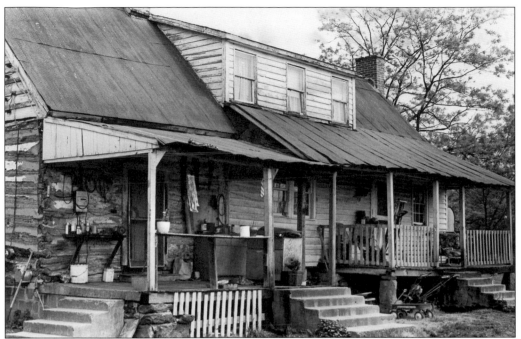

OLD CHISWELL PLACE, CATTAIL ROAD, POOLESVILLE. The earliest weatherboards were often rived, or split and smoothed with a drawknife; in some cases, they featured a bead or groove cut along the lower edge. An early newspaper advertisement described this structure as a framed dwelling house. It subsequently added a log kitchen, and a two-story brick house was attached by owner William Chiswell in the 1820s. (Author photograph.)

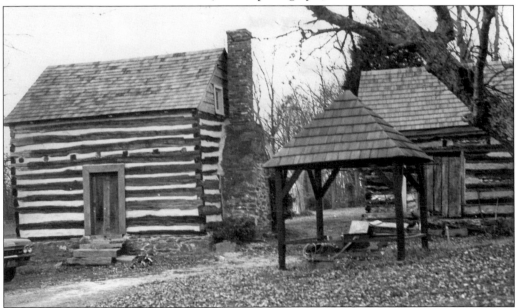

LOG SLAVE QUARTERS AT EDGEHILL, LAYTONSVILLE. Such structures as these, while once numerous, are now extremely rare. One visitor to the county described a slave dwelling "as a black hole without any window, which served as the kitchen and all other offices, and also as the lodging of the blacks." (Author photograph.)

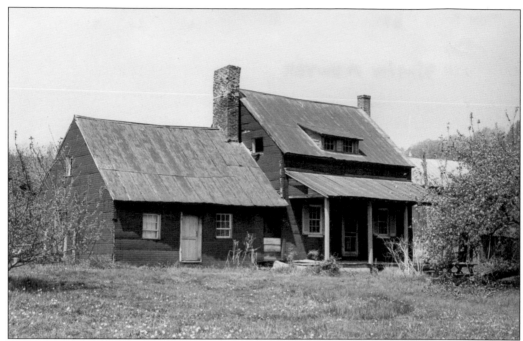

JOHN TAYLOR HOUSE, THOMPSON'S CORNER. Although wrapped in asphalt siding in this 1970s photograph, the steep roofs, large chimneys, and small windows are evidence of the house's early origins. Despite its unattractive exterior, the interior of this house featured ornate mantels and other fine woodwork. (Author photograph.)

TENANT OR OVERSEERS CABIN, NORWOOD. This is another rare example of an early dwelling that survived into the 1970s. This house, most likely built of logs, was connected to the adjacent Pleasant View Plantation next door to Blake High School. (Author photograph.)

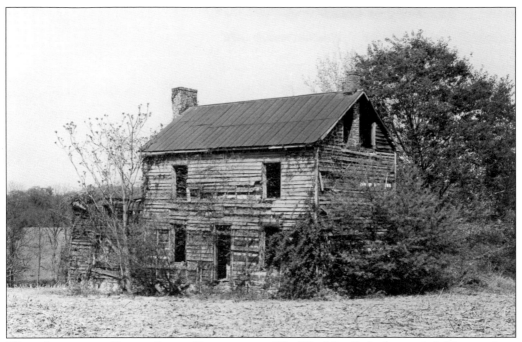

WARD LOGHOUSE, COMUS ROAD, BARNESVILLE. The Ward family had occupied this area since the 18th century and operated a mill nearby in the late 19th century. (Author photograph.)

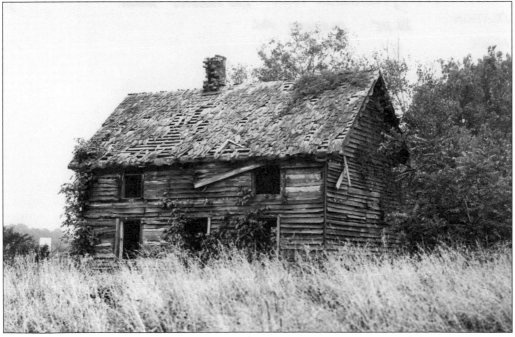

LOG TENANT HOUSE, FLOWER VALLEY. The earlier roofs were of wood shingles but were often covered with more durable metal by the 20th century. The longevity of a wood-shingled roof was ensured by shaving the shingles smooth with a draw knife, lapping them sufficiently, and then maintaining them—all things that took a lot of time, hence their discontinued use. (Author photograph.)

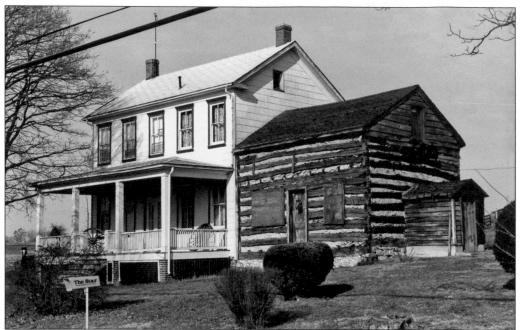

GRUSENDORF HOUSE, GERMANTOWN. The oldest log portion of this house was moved from its location at Clopper Road and Great Seneca Highway in Old Germantown to Seneca State Park. The original German settlement was located around the intersection of Routes 117 and 118. With the arrival of the railroad, the town moved east to its present location. (Author photograph.)

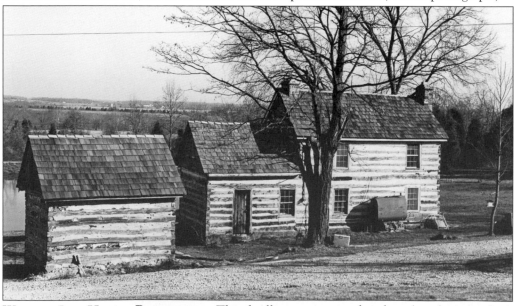

WILLARD LOG HOUSE, POOLESVILLE. This dwelling was restored and used as the caretaker's residence at the Bethesda–Chevy Chase (BCC) Chapter of the Izaak Walton League near the Potomac River. In 1871, the farm was sold to brothers Charles and Dewalt Willard. There are Willard Roads on both sides of the river attesting to the interaction between Maryland and Virginia in this area. The Willard family continues to operate several successful agricultural enterprises. (Author photograph.)

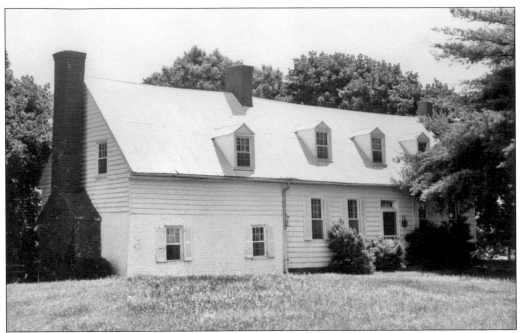

FERTILE MEADOWS, BRINK ROAD, GOSHEN. This *c.* 1800 house is unusual, as it features a frame section built on top of a brick wall. The home of the Riggs family who owned and operated adjacent Goshen Mill in the 19th century, its last owners to farm were Lee and Brita Counselman. (Author photograph.)

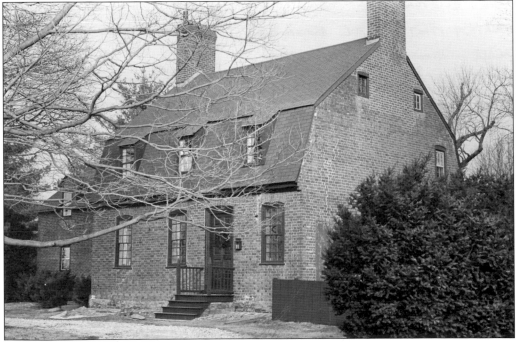

CLIFTON, ASHTON/SANDY SPRING. Regarded as the oldest house in Montgomery County, this was the home of the Thomas family for many generations, reportedly built *c.* 1742. Its most famous resident, however, may be its reported ghost, "Aunt Betsy." (Author photograph.)

Norwood, Sandy Spring. Among the most elegant and enduring early homes in the county are those built of brick by the Thomas family in the 18th century for their Quaker neighbors. Norwood was originally a Thomas family home later owned by the Moore and Bancroft families. (Author photograph.)

Falling Green, Route 108, Olney. Built in the 1760s for Basil Brooke by the Thomas family, Falling Green sits on a slight rise in the midst of rich farmland, now the site of the Olney Boys and Girls Club. The adjacent barn is a replacement for one built *c*. 1880 by David Frame, a local barn builder. (Author photograph.)

CHISWELL'S INHERITANCE, POOLESVILLE. In the western portion of the county, there were also a handful of brick Georgian houses. One of the finest was built in 1796 by Stephen Newton Chiswell. After being sold out of the family, it was repurchased in 1956 by descendent Mary Ann Kephart and her husband, George, a former Maryland–National Capital Park and Planning Commissioner. (Author photograph.)

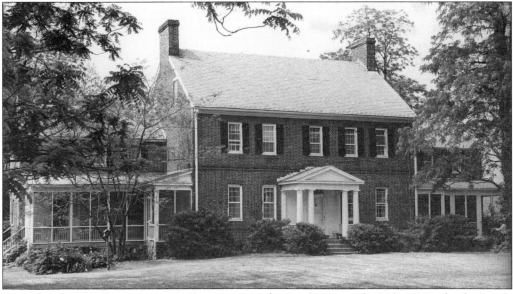

PLEASANT HILLS, DARNESTOWN. This property is known locally as the Kelley Farm for the family that owned the property for approximately 100 years. Dr. Kelley was a prominent surgeon, and one of his sons became a member of the first Montgomery County Council. The Offutt family also owned the farm, which has since been subdivided as part of W. C. and A. N. Miller's Spring Meadow Estates. (Author photograph.)

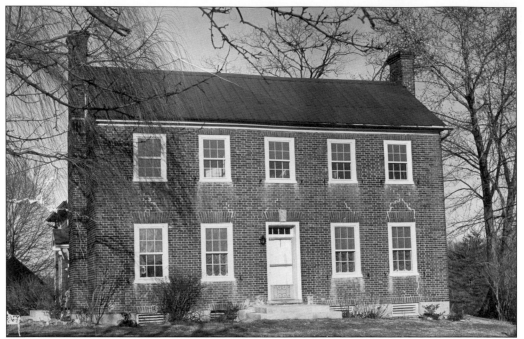

MAIDEN'S FANCY, BURTONSVILLE. The eastern section of the county features a ready supply of clay for brick making depending on one's finances and tastes. The transition between Georgian and Federal styles was sometimes subtle, as in the case of this fine brick house built in 1807. This was home to the Carr family during the 19th century. (Author photograph.)

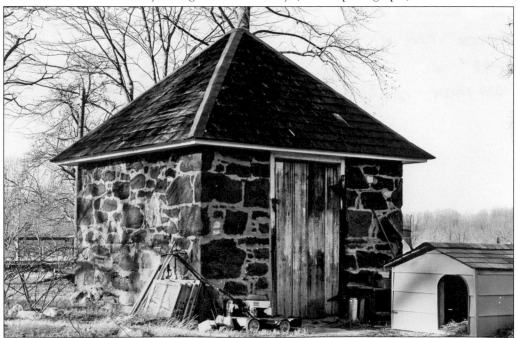

SMOKEHOUSE AT MAIDEN'S FANCY. Usually referred to as a "meat house" by rural residents, this example is unusual in that it is made of a rust-colored ironstone that occurs only in easternmost part of the county adjoining Prince George's County. (Author photograph.)

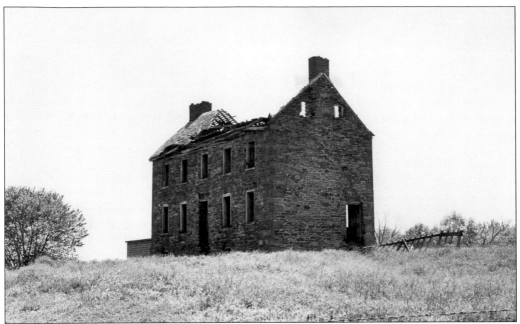

DAWSON HOUSE, SUGARLAND ROAD, POOLESVILLE. Continuously owned by the Dawson-Allnutt family since its construction in 1808, this fine example of stonework overlooked scenic Dry Seneca Creek. During the 19th century, the Dawsons operated a small gristmill here. (Author photograph.)

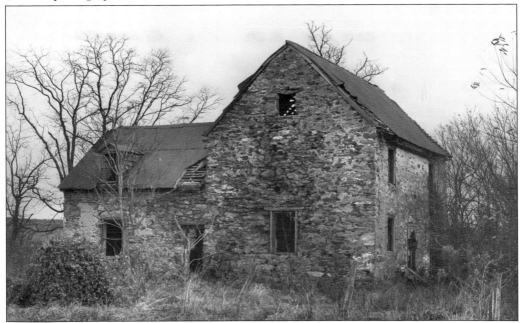

HOWARD HOUSE, UNITY. This dwelling was owned by the Howards, a remarkable African American family that rose from slavery to purchase not only their freedom, but also the plantation of their former owner. This house built of rubble stone dates from the 18th century and was the original house. A second house dates from the 19th century and was built by the Howards for their white tenant farmer. (Author photograph.)

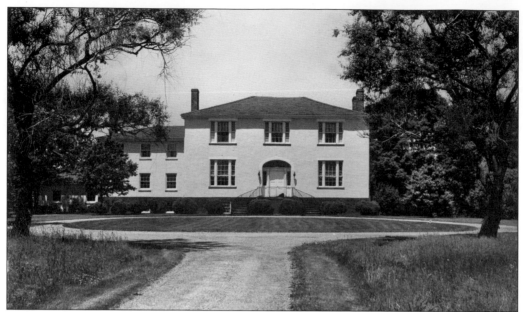

MONTEVIDEO, RIVER ROAD, SENECA. Constructed of Seneca sandstone, Montevideo was covered by stucco then scored to resemble ashlar blocks. This was the rural counterpart to Tudor Place, the fashionable Peter family home in Georgetown. Robert Peter was the first mayor of Georgetown, and his grandson, John Parke Custis Peter, built the house about 1830. John Peter was the first president of the Montgomery County Agricultural Society and the son of Martha Parke Custis Peter, granddaughter of Martha Washington. (Author photograph.)

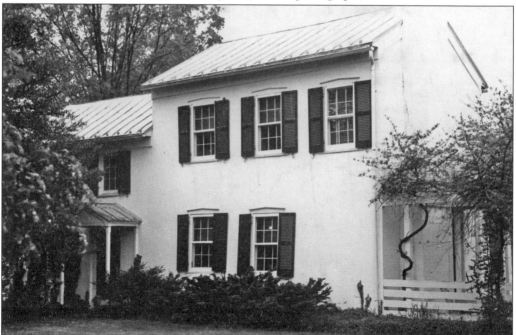

GAEGLER HOUSE, ROCKVILLE. This dwelling stood near Montrose Road, now site of the Jewish Community Center. It was also built of local stone and covered with stucco, probably to conceal the course rubble material used in its construction. (Author photograph.)

Four

COMMERCE
AND CONFLICT

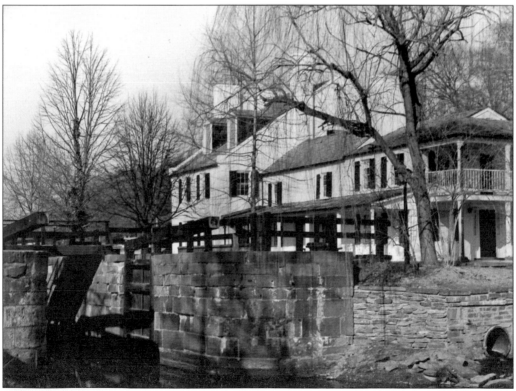

GREAT FALLS TAVERN, CHESAPEAKE AND OHIO CANAL. Known as the Crommelin House for the Dutch investors who financed its construction, the tavern was the scene of cotillions during the 19th century as well as overnight lodging for canal travelers. An earlier photograph of the tavern appears on page 17. (Author photograph.)

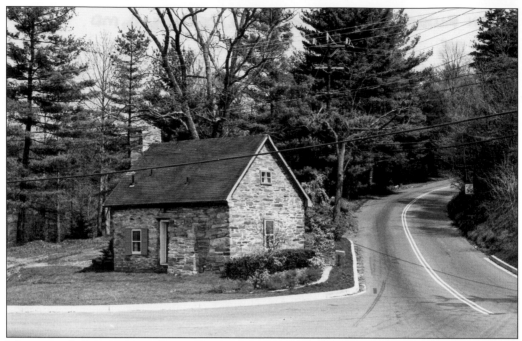

MAGRUDER'S BLACKSMITH SHOP, POTOMAC. Located at the corner of River and Seven Locks Roads, this is one of the county's oldest commercial structures. As late as 1910, there were still approximately 60 blacksmith's shops in the county. (Author photograph.)

OLD TAVERN, UNITY. Once located on a busy route to Annapolis via Green's Bridge Road, this old village has been almost forgotten. In its day, the tavern would have been surrounded by muddy stockyards where drovers rested their livestock on the way to market. (Author photograph.)

DARNESTOWN AT ROUTE 28 AND SENECA ROAD. Formerly one of the county's roadside villages, a number of Darnestown's structures were demolished in recent years. Darnestown was frequently mentioned in less than flattering terms by Union soldiers during the Civil War. One soldier said the town was "appropriately named, without further comment." (Author photograph.)

MURPHY'S TINSMITH SHOP, OLNEY. Once known as Mechanicsville for its numerous artisans, this crossroads village was demolished during the 1978 widening of the intersection. Originally a wheelwright and undertaker's shop, the site was also occupied by Hines Blacksmith Shop, which later moved across the road and became Finneyfrock's. (Author photograph.)

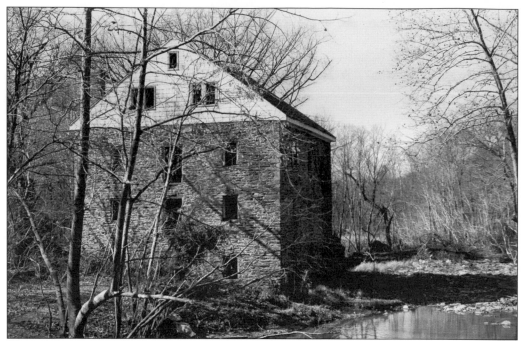

BLACK ROCK MILL, GREAT SENECA CREEK, DARNESTOWN. While many millraces can be found in the county's stream valley parks, surviving structures are rare. This gristmill and sawmill were built in 1815 and stabilized in the 1970s by the county as a bicentennial project. The mill is situated in a picturesque location in Seneca State Park. (Author photograph.)

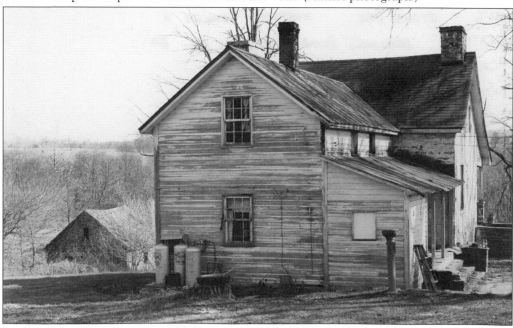

BROOKEVILLE WOOLEN MILL ON HAWLINGS RIVER. Shown in the lower left of this photograph is one of very few fulling or woolen mills in the region. It was probably built by Brookeville Quaker Richard Newlin and manufactured blankets and clothing for slaves by processing farmers' raw wool shorn from sheep each spring. (Author photograph.)

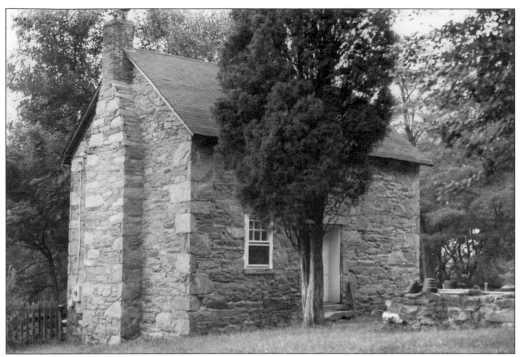

SLAVE QUARTERS AT FAR VIEW, NEAR BROOKEVILLE. Overlooking the Hawlings River Valley, this fieldstone structure was one of several on the farm featuring exceptional masonry, hence the reason for its survival. (Author photograph.)

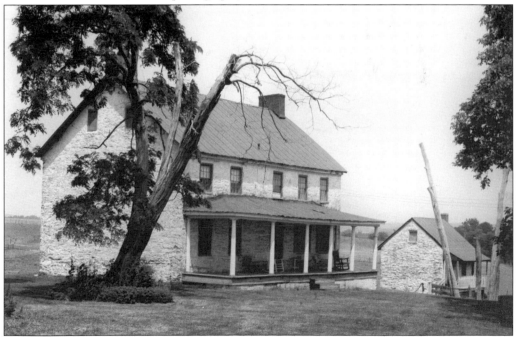

ROLLING ACRES HOUSE AND SLAVE QUARTER, SUNSHINE. Rolling Acres, home to the Gaither family, was built in 1806. This farm contains a number of fieldstone structures, including a large bank barn more typical of those found in counties to the north. (Author photograph.)

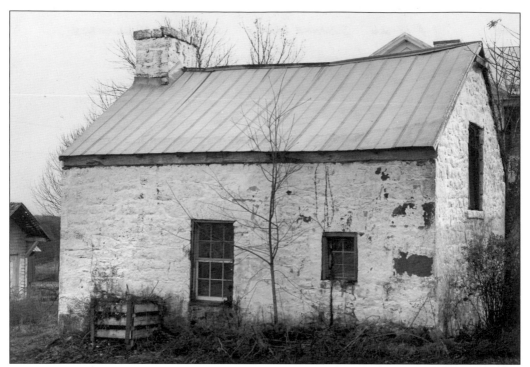

SLAVE QUARTERS AT SUSANNA FARM, DAWSONVILLE. Located adjacent to the large frame farmhouse once belonging to the Dyson Family, these sturdy-looking dwellings belie the misery caused by the system of slavery that eventually led to war. (Author photograph.)

NEEDWOOD MANSION, DERWOOD. Now part of Rock Creek Regional Park, this home was formerly known as Sunny Side. Wealth was no guarantee against misfortune, however, as the owner, William George Robertson, was killed by lightning at the outbreak of the Civil War. His wife was pregnant with their 11th child, and the eldest son joined Mosby's infamous Confederate rangers. The widow was forced to move back to Baltimore to live with her father after the war. (George Beall Collection.)

EDGEHILL, GRIFFITH ROAD, LAYTONSVILLE. Edgehill was home to eight generations of the Griffith family, who sent four sons to service in the Confederate army. These families came under scrutiny during the war and were frequently raided by Union patrols searching for rebels. These encounters sometimes turned violent, as in the case of an incident that took place at Mount Carmel, the Gott farm in Dickerson. (Author photograph.)

S. THOMAS MAGRUDER HOUSE, SENECA ROAD, DARNESTOWN. This house was occupied by Union general Nathaniel Banks early in the Civil War and connected to an extensive network of military features that included a signal station near River Road and a large camp with a blockhouse along the river at Muddy Branch. (Author photograph.)

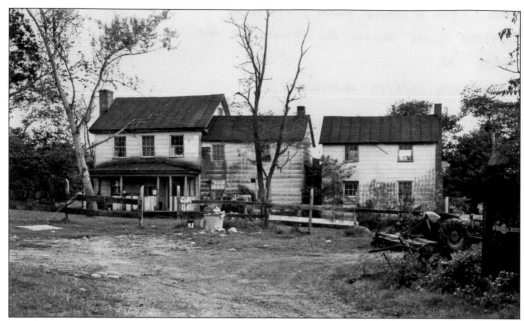

THOMAS WHITE FARM, POOLESVILLE. With the owners off to war and most of the slaves gone, Southern sympathizers in the county suffered heavy economic losses. Thomas White, one of the four sons-in-law of Mary Gott, served with fellow son-in-law Elijah Veirs White's Comanches. Not only did these farmers lose income from the farm, but they also lost much of their fortune that was invested in slaves. (Author photograph.)

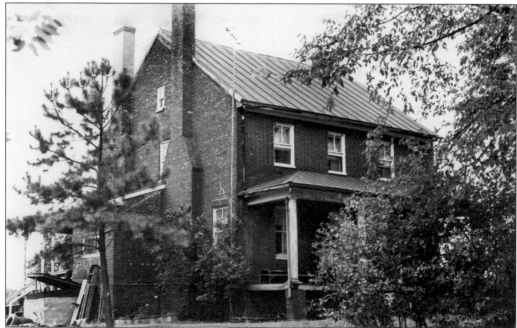

FISHER FARM, POOLESVILLE. This structure on Old River Road near White's Ferry, owned by the Butler and Poole families, was damaged by Union troops according to 20th-century owner Joe Fisher. Damaged further in a violent storm in the 1980s, the house had to be demolished. (Author photograph.)

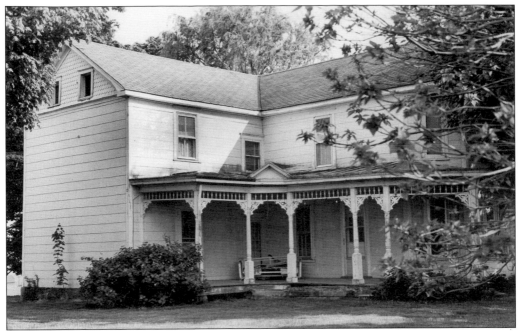

RICHTER-KING FARM, SCHAEFFER ROAD, GERMANTOWN. Lincoln assassination conspirator George Atzerodt was arrested here in 1864. Atzerodt had fled Washington seeking refuge with his relatives and was eventually tried, convicted, and hanged along with the other alleged conspirators. Atzerodt was turned in by his own brother, a deputy with the State Provost Marshall's Office. (Author photograph.)

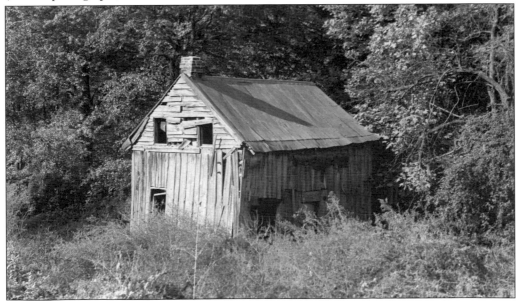

POST–CIVIL WAR AFRICAN AMERICAN HOUSING. This log cabin was located on Moxley Road in the Friendship community near Damascus. Former slaves found that their living situation was not dramatically different from before the war, as they often found themselves working for the same landowner. The major change was that they were now able to acquire small tracts of marginal land that they subdivided and sold to family and friends. (Author photograph.)

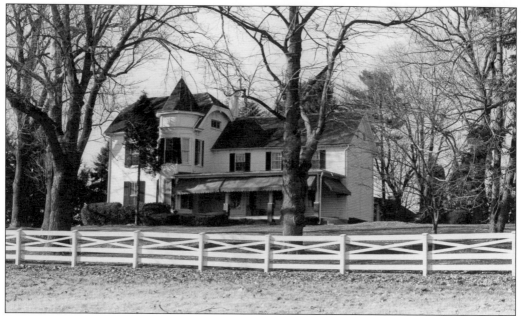

ASHLAND, MUNCASTER MILL ROAD, NORBECK. Ashland was the home of the Cashell family (pronounced like the Rock of Cashel). They were natives of Ireland who came to this country and began to farm as tenants. According to an 1898 document, this farm, a poor and unproductive piece of land, "by diligence and careful management . . . has become one of the most beautiful homes in the 6th Congressional District." (Author photograph.)

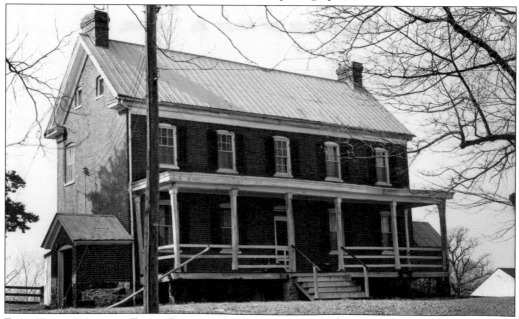

FORD FARM, POTOMAC FALLS, POTOMAC. This house was built in 1887 by a prosperous merchant who owned brickyards in Alexandria and Washington. One of several farms in this area to literally strike gold in the late 19th century, the owners were paid a fee by companies to prospect on their land. The old Ford Mine remains to this day in the adjacent Great Falls National Park on the Chesapeake and Ohio (C&O) Canal. (Author photograph.)

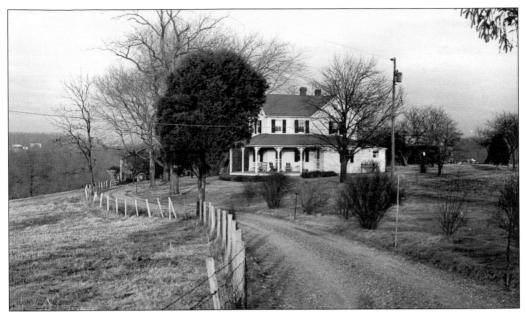

WILSON/LINK FARM, BROWNS BRIDGE, EDNOR. Most small farms continued to improve their lands using their own labor and improved farming techniques and equipment during this period. Adjacent to the Patuxent River, this farm contained deposits of soapstone, which had been used by Native Americans and settlers alike for bowls and hearths for fireplaces. (Author photograph.)

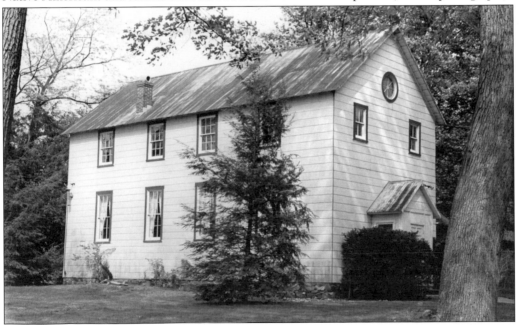

BRIGHTON GRANGE HALL, NEW HAMPSHIRE AVENUE, BRIGHTON. Farmers' societies began to organize throughout the county to promote agricultural improvements that had formerly been available only to the wealthiest class of farmer. Although eventually there were grange halls throughout the county, the one at Brighton was referred to as "celebrated," having hosted the state's first Farmer's Institute in 1890, which was the forerunner of the Extension Service operating to this day. (Author photograph.)

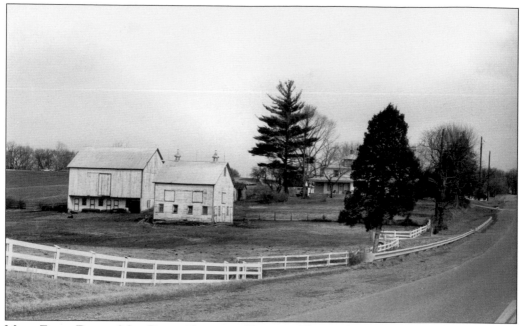

MILLS FARM, DUFIEF MILL ROAD, TRAVILAH VICINITY. The number of small dairy farms increased in the early 20th century. At that time, farmers were using typical framed barns, but by the 1920s and 1930s, they were forced to invest in concrete-block structures due to the increasingly strict health codes. (Author photograph.)

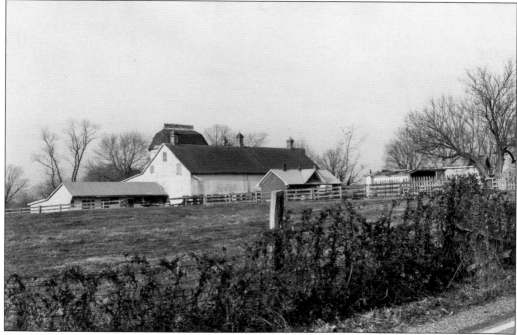

BRIGGS FARM, WEST OF GAITHERSBURG. Fronting Old Quince Orchard Road at Longdraft Road, this farm was an early-20th-century model dairy farm last owned by W. O. Johnston. Mr. Johnston's grandfather was W. O. Dosh, who owned this farm and a livery stable in Gaithersburg as well. (Author photograph.)

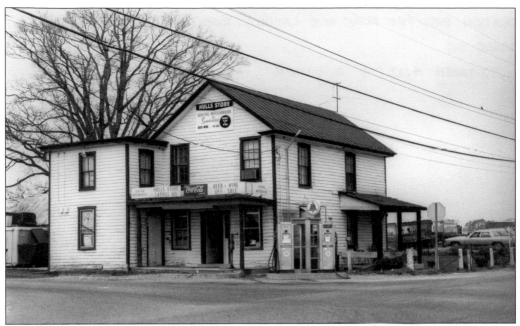

HULLS STORE AT LAYHILL AND BEL PRE ROADS, LAYHILL. Originally known as Beall's Store and Post Office, this structure dates from *c.* 1898. The Beall family settled here in the early 18th century and patented tracts of land they named Bel Pre and Lay Hill. The building was demolished for the widening of the intersection. (Author photograph.)

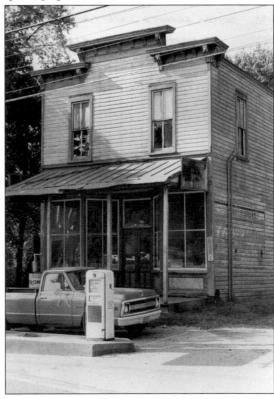

RIORDAN'S STORE, LAYTONSVILLE. Originally known as Dwyer and Griffith's Store for the old area families who began it in 1898, this store was owned for years by Guy Riordan and his sister, Cathryn. It was demolished in 1975 for intersection improvements. (Author photograph.)

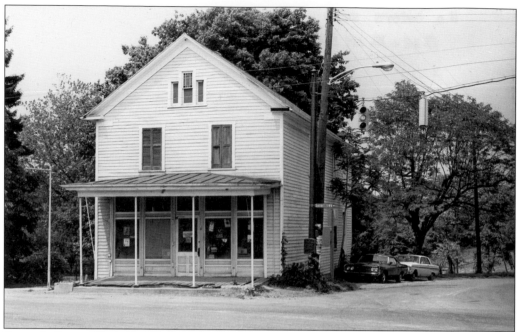

DARBY'S STORE, BEALLSVILLE. Situated at a high point at Routes 28 and 109, this was originally called Medley's Hill, a name also given to the local election district. Across the street is the Monocacy Cemetery, which contains the tombstones of many area residents, including a shrine to Confederate veterans. (Author photograph.)

HUNTING HILL STORE AND POST OFFICE, ROCKVILLE. Formerly located on the farm of Elizabeth Banks, this enterprise was once operated by her grandfather, Ignatius Beall Ward. Miss Banks was well known for preserving her beautiful farm while being surrounded by development. (Author photograph.)

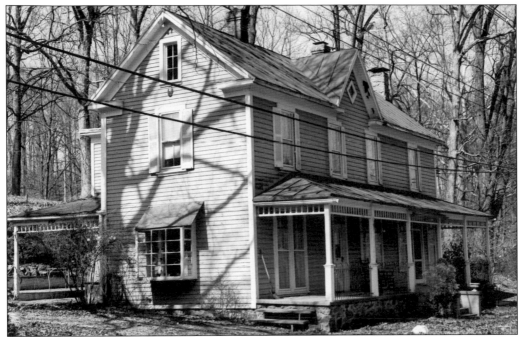

GLEN STORE AND POST OFFICE AT GLEN MILL AND SOUTH GLEN ROADS, POTOMAC VICINITY. This was once a small, out-of-the-way community where a mill stood on Watts Branch. The Peters family once operated both the store and mill. The store is now a private residence. (Author photograph.)

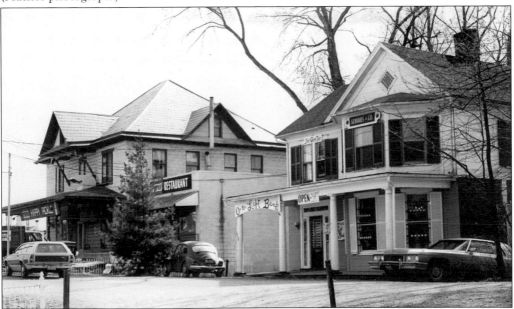

RIVER AND FALLS ROADS, POTOMAC. Once known as Offutt's Crossroads, the buildings shown in this 1974 photograph include the old Perry House, which was occupied by the Happy Pickle Deli. Across the street was Perry's store, now occupied by a bank. When faced with road improvements, this intersection fared better than most, as the historic buildings were preserved and nicely restored. (Author photograph.)

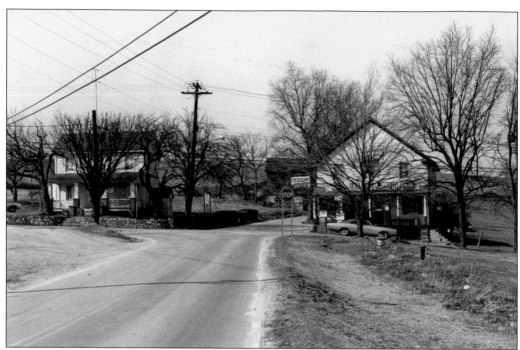

LEWISDALE STORE NEAR HYATTSTOWN. At the corner of Price's Distillery and Browningsville Roads is another small community unknown to most county residents. An earlier photograph of the store appears on page 16. (Author photograph.)

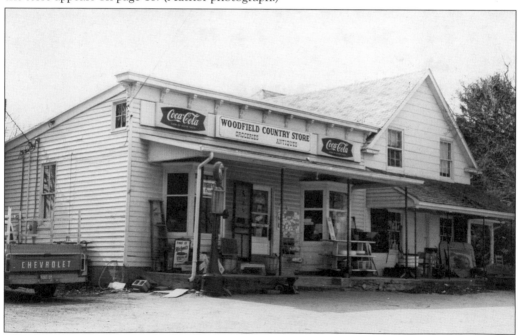

WOODFIELD COUNTRY STORE, DAMASCUS. Still in service along Route 124, this store was started about 1880 by Thomas Woodfield. It was subsequently purchased and operated by the Hawkins family for more than 80 years. Along with the nearby Methodist church, it is the focal point of this small community. (Author photograph.)

Five

Houses of Worship
and Other Houses

Brighton Centennial Church, New Hampshire Avenue, Brighton. An exceptional example of an African American church in a community of free blacks, the church was abandoned, fell into decay, and collapsed shortly after this picture was taken. (Author photograph.)

OLD STONE BAPTIST CHURCH, DAWSONVILLE. Unusual in Montgomery County, this church's style is similar to other small stone meetinghouses on the Virginia side of the river in Loudoun County. Converted years ago into a private residence, it is included in the boundaries of Seneca State Park. (Author photograph.)

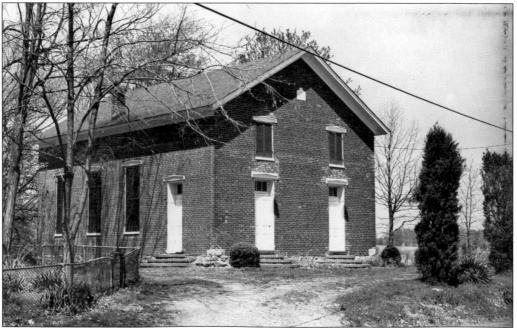

SUGARLOAF MOUNTAIN CHAPEL, COMUS. On the site of an octagonal log church visited by Methodist bishop Francis Asbury in 1788, the present structure was built in 1856 by William Hilton of Barnesville. The material for the roof came from the Hyattstown slate quarry, which had employed Welsh slaters in its early years. (Author photograph.)

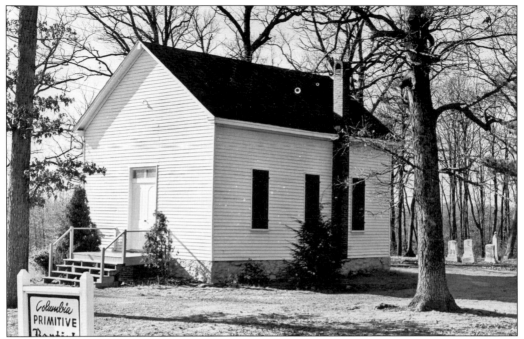

COLUMBIA PRIMITIVE BAPTIST CHURCH, BURTONSVILLE. Established in 1855 by a congregation from Howard County, the present church is an 1880 replacement for an earlier one that burned. A classic simple framed country church, this structure stands in a quiet grove of trees in stark contrast to the heavy flow of traffic on its way to Howard County. Members of the congregation included the Waters family, who lived nearby since the 18th century. (Author photograph.)

SAINT MARKS EPISCOPAL CHURCH, FAIRLAND. Demolished when the new church was constructed, this board-and-batten Gothic Revival building was a popular design for Episcopal churches in the 19th century. (Author photograph.)

TRAVILAH BAPTIST CHURCH, GLEN ROAD, TRAVILAH. Yet another country church to disappear in recent years, this simple frame structure was built in 1898 and was one of the few remaining landmarks in an area that has witnessed dramatic changes with the construction of many large and expensive homes. (Author photograph.)

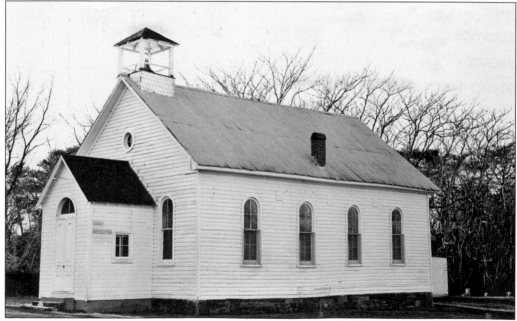

SAINT PAUL'S CHURCH, SUGARLAND ROAD, POOLESVILLE. A very handsome but simple structure, St. Paul's still serves an African American congregation despite having lost its rural membership over the years. Some of the early settlers were Patrick Hebron, Nancy Dorsey, and William Taylor. (Author photograph.)

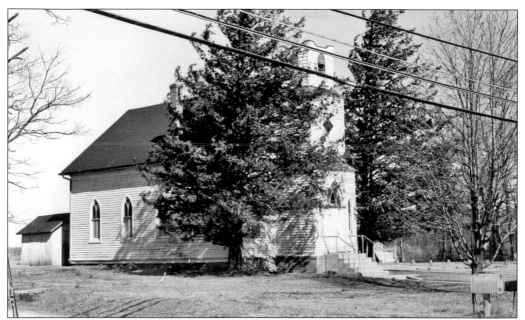

McDonald Chapel at Quince Orchard. Formerly located at the corner of Route 28 and Quince Orchard Road, McDonald Chapel was one of a number of old frame country churches lost to development during the 1970s. Around 1895, local families like the Howards and the Mills formed a congregation. The structure was built about 1899 under the direction of Rev. William A. McDonald, for whom it was named. (Author photograph.)

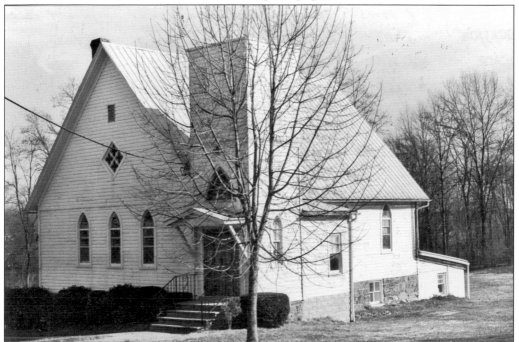

Trinity Methodist Church, Germantown. Located in the heart of New Germantown, this structure was replaced by a new Buddhist temple established by one of the county's many immigrant populations. (Author photograph.)

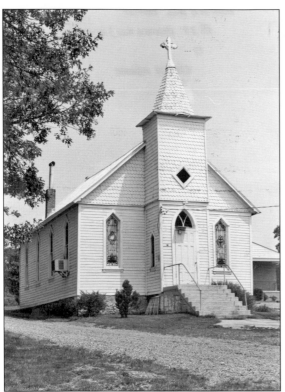

HUNTING HILL BAPTIST CHURCH, ROUTE 28 WEST OF ROCKVILLE. This was one of many picturesque churches in the county and one of the last buildings to mark the old community place name. (Author photograph.)

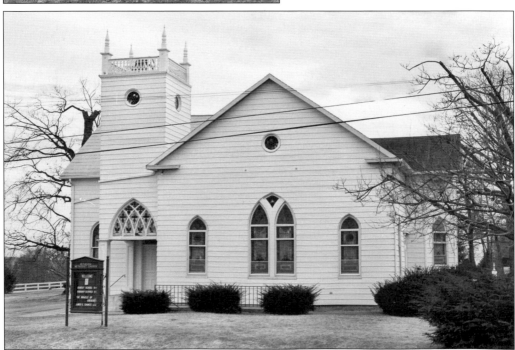

BETHESDA UNITED METHODIST CHURCH, BROWNINGSVILLE. This is yet another church demolished when it outgrew the needs of the congregation. The stained-glass windows were retained for inclusion in the new structure. (Author photograph.)

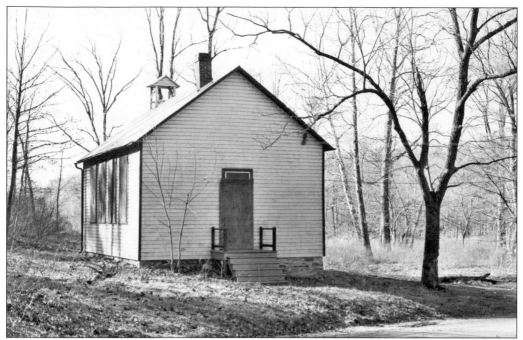

KINGSLEY SCHOOL IN LITTLE BENNETT PARK, HYATTSTOWN. Known locally as Froggy Hollow School, this one-room building is situated in a very isolated but picturesque spot beside Little Bennett Creek. This school was built in 1893 for the children of local white farmers who would only attend class when not needed to help on the farm. (Author photograph.)

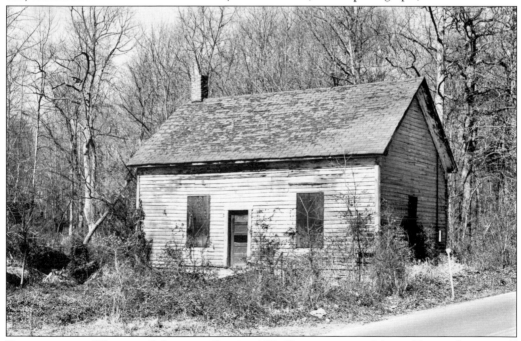

BROWNSTOWN "COLORED" SCHOOL, ROUTE 118, GERMANTOWN. Many older residents recall being bussed to Rockville if they wished to continue their education beyond the elementary level. Refer to the map shown on page 47. (Author photograph.)

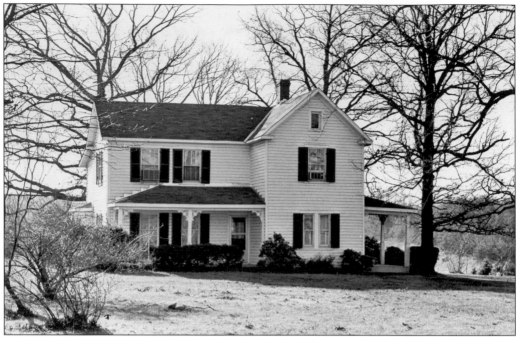

FRAME FARMHOUSE, SOUTHEAST CORNER OF ROUTES 29 AND 198, BURTONSVILLE. As the county progressed, the simple frame farmhouses began to acquire details such as the bracketed posts seen on this otherwise straightforward residence. (Author photograph.)

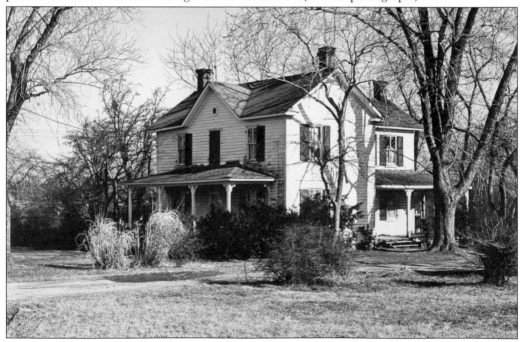

FRAME FARMHOUSE, NORTHEAST CORNER OF ROUTES 29 AND 198, BURTONSVILLE. By the mid-19th century, Gothic and other Revival styles based on European architecture of centuries before began to appear in this country. This was owned in the 20th century by the Parsley family, (Author photograph.)

GRIFFITH FARM HOUSE, WOODFIELD ROAD, GOSHEN VICINITY. Many houses contained a number of "revival" features during the boom in Victorian architecture. The most common element seen in the county was the omnipresent center gable, like the one shown on this house, which was demolished for development during the 1980s. (Author photograph.)

THE HIGHLANDS, BROWNS CORNER NEAR SPENCERVILLE. Prior to its demolition for a WSSC sewage sludge disposal site, this house displayed Gothic arches on almost every one of its sections. This was the home of Robert Miller, who was director of the University of Maryland Experimental Station. (Author photograph.)

TILGHMAN HERSBERGER HOUSE, SUGARLAND ROAD, POOLESVILLE. Sometimes the center gable became the dominant feature of the house, such as with this prosperous farm dwelling located in a somewhat isolated corner of the county. (Author photograph.)

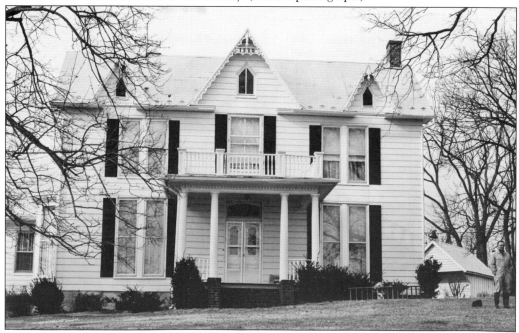

MENDELSSOHN TERRACE, BROWNINGSVILLE. The home of the Walker family for many generations, this Gothic 1880s dwelling replaced the small, primitive log house that had served as the family home for years. Its name is derived from owner, George Wesley Walker, who was a professor of music. His son formed the famous Browningsville Band in 1884, which is still in existence today. (Author photograph.)

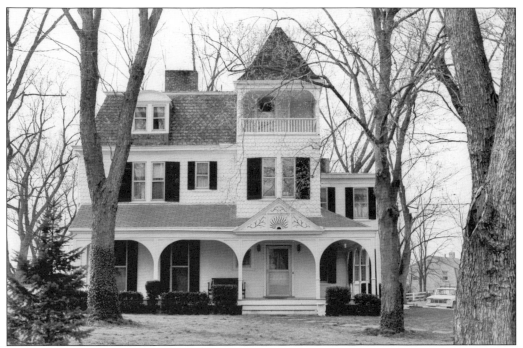

WESTOVER, RANDOLPH ROAD, COLESVILLE. The original home was owned by the Thomas family and remodeled in the popular Queen Anne style during the Bradley ownership. One of the distinguishing characteristics of this style was the tower built in the front corner. (Author photograph.)

SOMERSET, BETHESDA. The Queen Anne style was also popular with the young professionals who established this community near the District line about 1890. The streets were named after English counties, and sales literature claimed that residents could exercise their "taste in landscape gardening, and ornamental architecture." (Author photograph.)

OLDS HOUSE, WOODSIDE, SILVER SPRING. Some houses were eclectic mixtures of style, which was befitting of this house, built by Mabel Bradford and Edson B. Olds after Ms. Bradford's fiance bet a man that he could eat poison ivy without harm. Unfortunately the bettor died, leaving his property to Ms. Bradford who then married Mr. Olds, according to the late Mildred Getty. (Author photograph.)

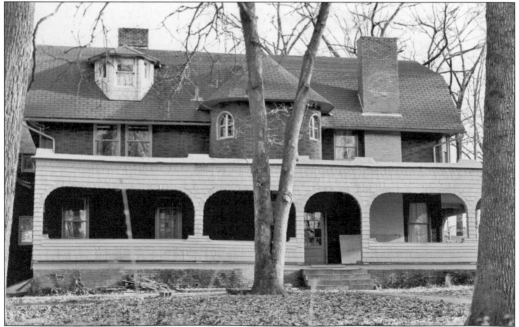

BOAT HOUSE, TAKOMA PARK. Some of the most unique housing designs were built in this early commuter suburb adjacent to the District. In recent years, its boundaries have been brought entirely into Montgomery County, making it one of the largest historic districts in the region. (Author photograph.)

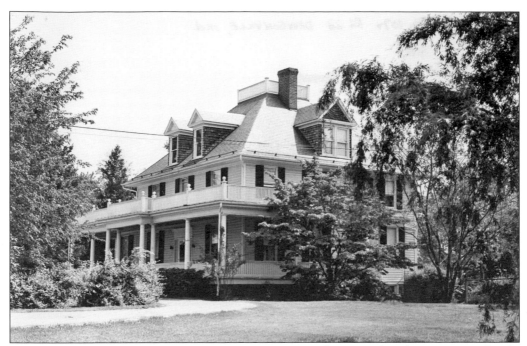

DOCTOR UPTON D. NOURSE HOUSE, DAWSONVILLE. Built in 1914 for a longtime-area family, this house is recognized as one of the finest examples of Colonial Revival architecture in the county. Local builder George Stang included offices for the medical practice of owner Dr. Nourse (pronounced "nurse"). (Author photograph.)

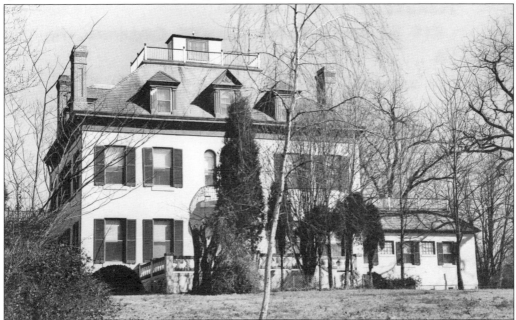

TSCHIFFELY-KENT MANSION, KENTLANDS, GAITHERSBURG. The Tschiffely family had this impressive building constructed in 1901. Another example of a sophisticated residence located in the up-county, it later became the Kentlands Estate of Otis Beall Kent and is now owned by the City of Gaithersburg. (Author photograph.)

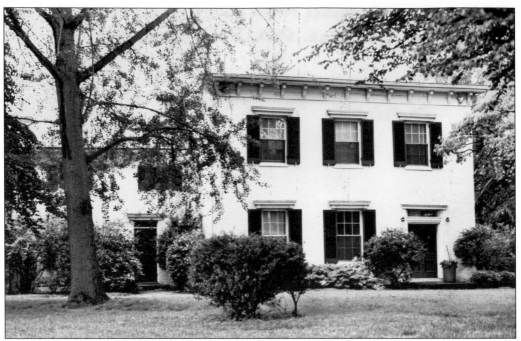

LYDDANE-BRADLEY HOUSE, ROCKVILLE PIKE, ROCKVILLE. Built in the mid-19th-century in the Italianate style, this handsome brick house was later a dairy farm operated by the Bradley family and currently belongs to Woodmont Country Club. (Author photograph.)

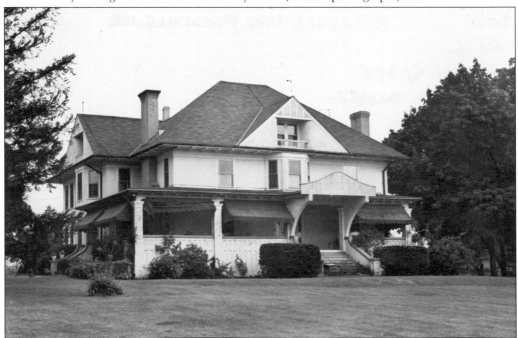

ROCKY GLEN FARM, ROCKVILLE PIKE, ROCKVILLE. Although his family's roots were in Dawsonville, Henry Dawson moved west but returned to the farm in 1911. His wife, Fanny, designed this unusual style to remind her of their prairie years. Their daughter "Miss Rose" Dawson is remembered by many county residents for maintaining an Indian Room in the house. (Author photograph.)

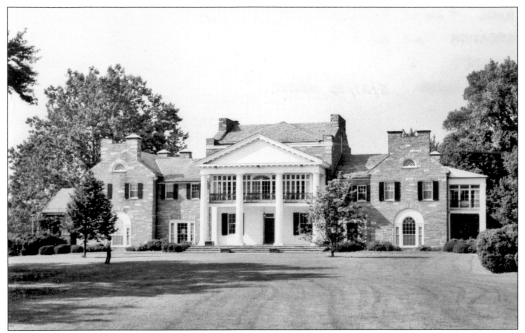

GLENVIEW, ROCKVILLE CIVIC CENTER, ROCKVILLE. The early-19th-century home of Judge Richard Johns Bowie was remodeled in the early 20th century by Dr. James A. Lyon. It became the home of the Montgomery County Historical Society in 1953 before being sold three years later to the City of Rockville. (Author photograph.)

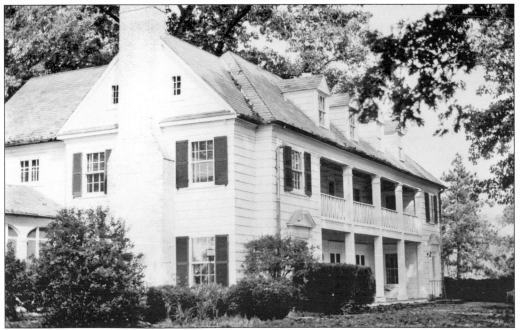

MONUMENT VIEW HILL, SHADY GROVE ROAD, GAITHERSBURG. Located on the site of an old sanitarium known as Starmont, this became the 1930s home of Eugene B. Casey, an aid to Franklin D. Roosevelt. It was demolished to make way for the I-370 expressway to the Metro station. The Casey dairy barns remain nearby. (Author photograph.)

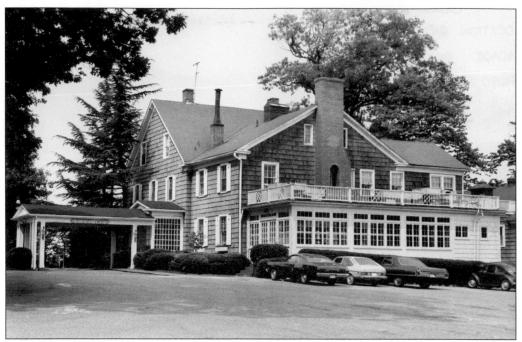

OLNEY INN, GEORGIA AVENUE, OLNEY. Originally the 1870s farmhouse of Granville Farquhar, this structure became one of several popular country restaurants in the county during the early to mid-20th century. This is one of several Olney landmarks to burn in the 1980s. (Author photograph.)

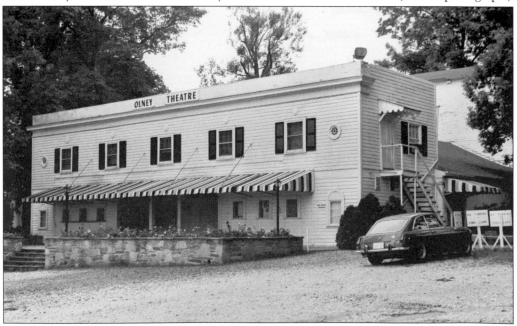

OLNEY THEATRE, OLNEY/SANDY SPRING ROAD, OLNEY. Currently undergoing major expansion, this entertainment venue began modestly enough in the 1930s but eventually grew to become Maryland's official summer stock theater. Critically acclaimed first-run plays attracted local dignitaries such as Secretary of the Interior Harold Ickes of Olney and Secretary of State Dean Acheson of Sandy Spring. (Author photograph.)

Six

CHANGING
RURAL LANDSCAPE

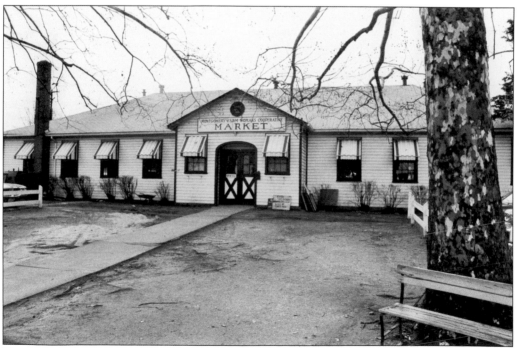

THE FARM WOMEN'S MARKET, BETHESDA. During the Great Depression, as the nation sank under the weight of the failing economy, once again the county's farm community rose to the occasion. The home demonstration clubs which were part of the county's extension service cast about for a way to ease the plight of the farmers. In 1932, they established the Farm Women's Cooperative in the present building, which has been little changed since that time despite its urban location. (MNCPPC Archives.)

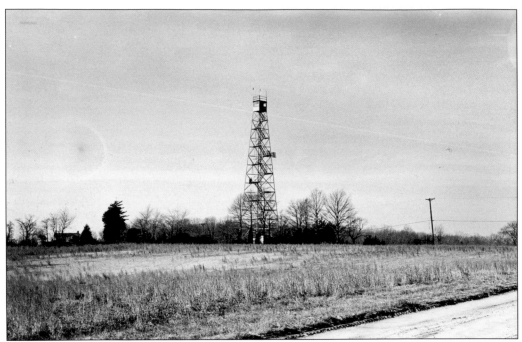

BURTONSVILLE FIRE TOWER, ROUTE 29, BURTONSVILLE. Seemingly out of place as it still stands amidst booming development adjacent Route 29, the Burtonsville Fire Tower now has few fields or forests to watch over since this photograph was taken in 1973. (Author photograph.)

TENANT HOUSE ON MULLINIX FARM, DAMASCUS. Once numerous in the county, similar dwellings have largely disappeared as the farm labor force left for better opportunities and standards of living rose. Mechanization has helped somewhat to ease the chronic labor. (Author photograph.)

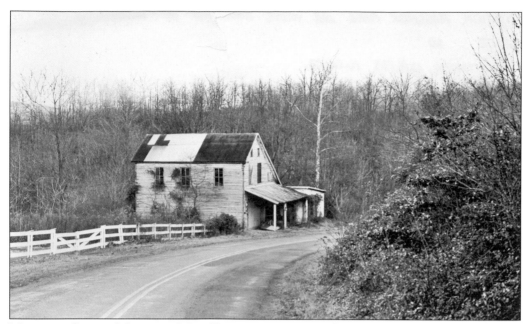

MULLINIX STORE, MULLINIX MILL ROAD, DAMASCUS. The store was named for the family who also operated grist and cider mills nearby during the 19th century and continues to farm to this day. As the farm population decreased, the old network of businesses that served them also disappeared, sometimes erasing all evidence of the small communities that they had formed. (Author photograph.)

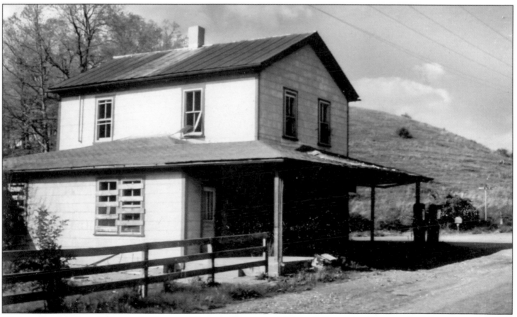

WHITE'S STORE, WHITE'S STORE ROAD, BOYDS. White's is one of several old country stores that fell victim to arson or decay before the author began his official survey. Another example was Windsor Store at Darnestown, which burned in 1971. This store was owned and operated by "Harry" Boteler White from his retirement from farming in 1936 until his death in 1950. (Author photograph.)

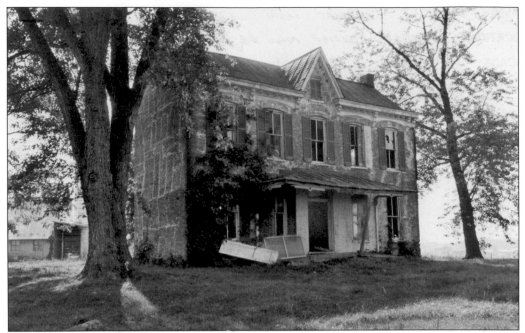

GARRETT-WARD FARM, ROUTE 28 AND DUFIEF MILL ROAD, ROCKVILLE. A ghostly landmark that sat high on a hill overlooking Darnestown Road, this structure was photographed in 1972 but had disappeared within a year or so. This was one of the homes of the Garrett and Ward families, who were well known farmers in this neighborhood. (Author photograph.)

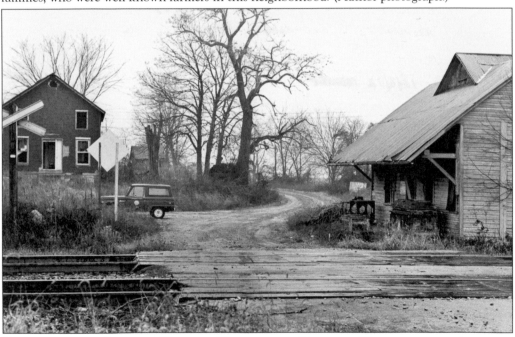

BARNESVILLE OR SELLMAN STATION, BARNESVILLE VICINITY. These structures shown are Darby's Store on the left and the old railroad station building on the right. A virtual ghost town in 1972, this old railroad depot had all but evaporated by the time of the author's survey. (Author photograph.) ·

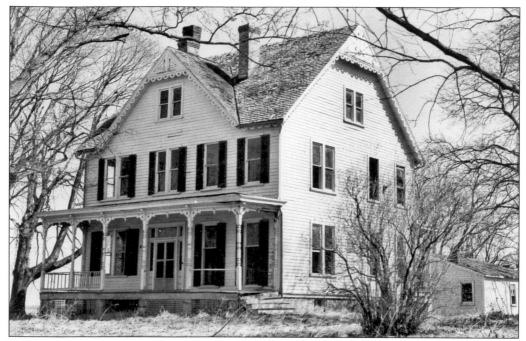

KING FARM AT ROUTE 27 AND BRINK ROAD, GERMANTOWN VICINITY. The former home of successful farmer and businessman Lawson King, this Victorian residence overlooked miles of rolling fields in every direction. A water storage facility occupies this site today. King was best known for his Irvington Farm on Route 355 near Shady Grove Road, where he maintained one of the largest herds of Black Angus cattle in the state. (Author photograph.)

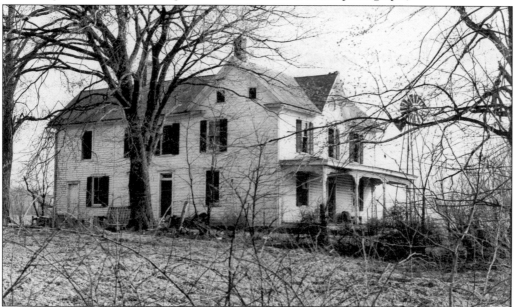

ABANDONED FARMHOUSE OFF WATKINS ROAD, WOODFIELD. This is one of many abandoned farmhouses encountered during the author's survey. Small farms were particularly vulnerable during the booming growth of the up-county as the value in land far exceeded farm income. (Author photograph.)

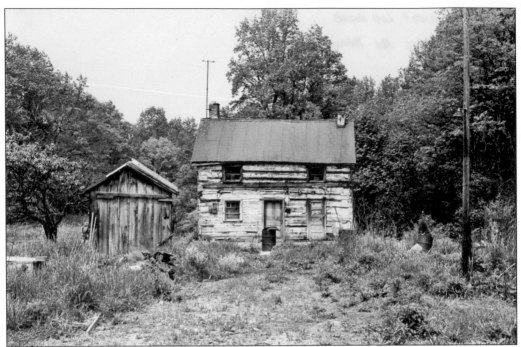

Loghouse at Jonesville, Beallsville Vicinity. This is a typical example of post–Civil War housing in the rural black communities that dotted the up-county. Such structures disappeared as rural inhabitants continued their exodus to the city. (Author photograph.)

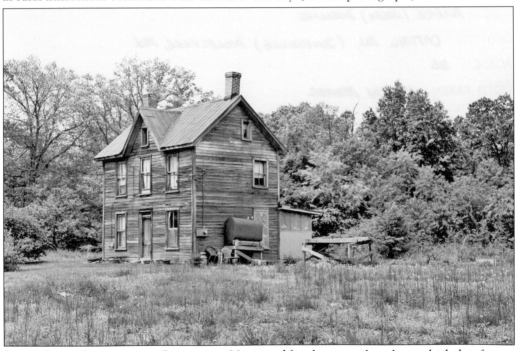

Later-Style Farmhouse at Jonesville. Unpainted farmhouses such as these, which date from *c.* 1900, were replacement dwellings for log houses. These houses, if located in the Deep South, would have been described as "too poor to paint and too proud to whitewash." (Author photograph.)

GRIFFITH STONE SPRINGHOUSE, WHITE STORE ROAD, BUCKLODGE. With its wood-shingled roof, brick diamond-pattern vent, and whitewashed stone walls, picturesque farm buildings like this outgrew their usefulness and have largely disappeared from the landscape. (Author photograph.)

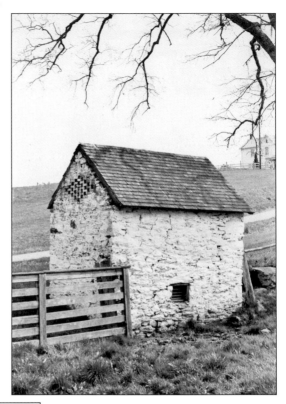

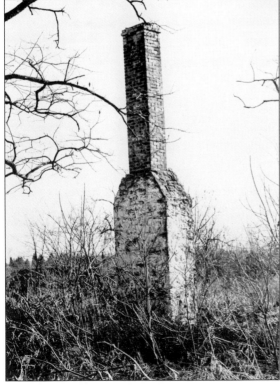

JARBOE CHIMNEY RUINS, HUGHES ROAD, POOLESVILLE. Often the only remaining evidence of a family's occupation was an old chimney. This area of the county was less populated, as the farms were larger here, so every loss has an added impact. (Author photograph.)

SNYDER HOTEL OR MONTGOMERY INN, RIDGE ROAD, DAMASCUS. This is one of very few roadside landmarks remaining from the early automobile age. The late Malcolm E. King recalled attending a chicken supper here following his graduation from the University of Maryland. (Author photograph.)

DOWNTOWN DAMASCUS, ROUTES 27 AND 108. Traditionally an up-county commercial center, Damascus has retained its small-town atmosphere despite the loss of familiar landmarks like Bellison Store, shown on the left. The store was established by Russell Duvall in 1915 and later owned and operated by Robey Miles. (Author photograph.)

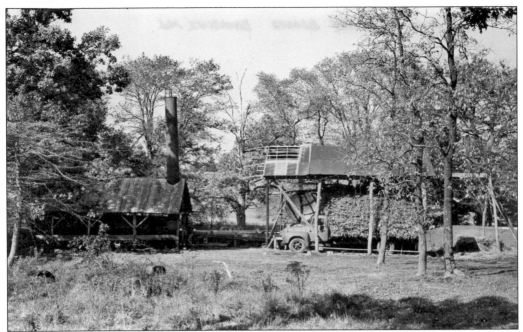

WORMWEED STILL, KEMPTOWN NEAR DAMASCUS. Unique to this small section of the state, this weed-like crop was distilled in steam vats and the liquid extract used in the 19th century for veterinary medicine and later sold to Europeans for perfume. It was grown because its price had reached as high as $9 per pound in the 1930s. (Author photograph.)

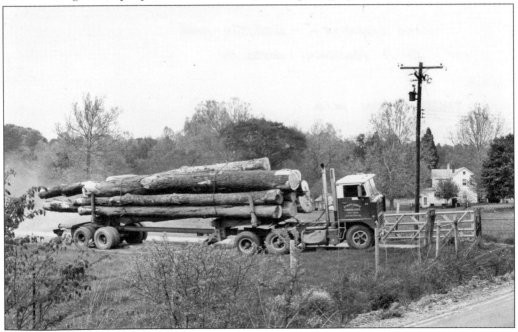

LOGGING AT OLD NICHOLSON FARM, BUCKLODGE, BOYDS. Despite being largely cleared for cropland, in its early years, the county maintained an ample supply of woodland available for harvest. During the past several decades, however, almost all of the old sawmills have faded from the scene. (Author photograph.)

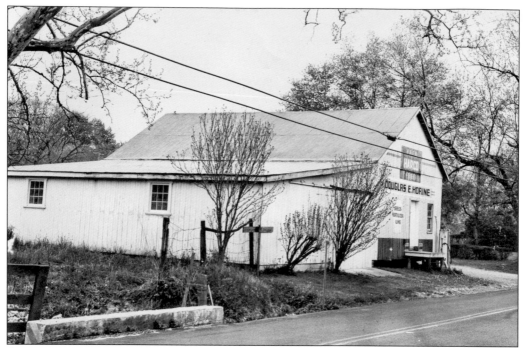

HORINE FEED STORE, BUCKLODGE ROAD NEAR BOYDS. Also vanished in recent years are most of the small feed stores that served the surrounding agricultural community. This structure remains, although its sign has been painted over. (Author photograph.)

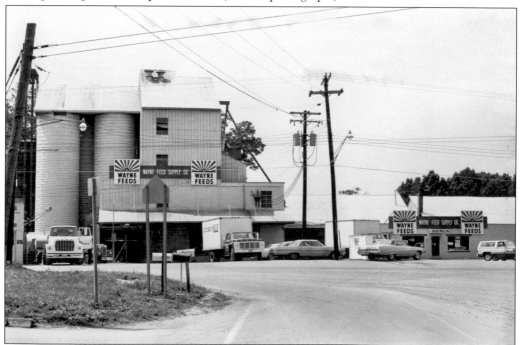

WAYNE FEEDS AT WASHINGTON GROVE, ADJACENT TO GAITHERSBURG. One of the larger grain mills located along the railroad in Gaithersburg, this facility was begun by the Fulks family and subsequently operated by the Lawson King family. (Author photograph.)

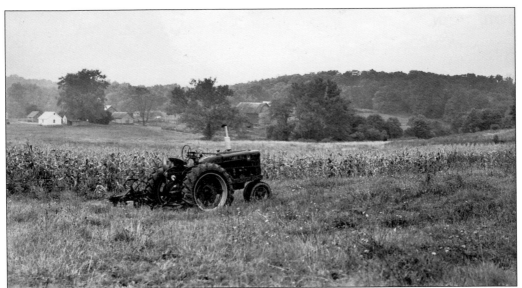

MILTON FARM, MUNCASTER MILL ROAD, NORBECK. The low-slung 18th-century house was replaced by the Muncasters in 1897. They had created a farming dynasty along with their relatives the Robertsons, Cookes, and Magruders. William E. Muncaster served as president of the old Rockville Fair, and his son, John, was its secretary for almost 40 years. The last owner of the farm was businessman William R. Winslow, who became president of the new County Fair after it relocated to Gaithersburg. Now this is the site of the Meadowside subdivision named for the county nature center located adjacent. (Author photograph.)

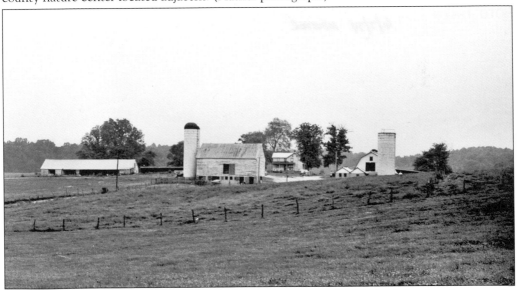

HOOVER FARM, DERWOOD. Originally a farm belonging to the Holland family, who gave the name to the Hawlings River near Brookeville, this farm was located in the fertile Upper Rock Creek Watershed, which was the focus of numerous conservation efforts in the 1950s and 1960s. As early as the 1890s, Congress had protected Rock Creek in the District by designating it as parkland. As its headwaters begin in Montgomery County, 30 miles upstream near Laytonsville, the county also acquired land along its banks and enacted low-density residential zoning as a buffer. (Author photograph.)

RABBIT FARM, GERMANTOWN VICINITY. During the 1970s, farmer Herman Rabbit caused a sensation by burying close to a million dollars in milk cans on one of his farms. Although he had a reputation as being somewhat eccentric, he was a shrewd businessman who had also provided land for the fairgrounds in Gaithersburg at a discount. (Author photograph.)

SILVER SPRING FARM, DAMASCUS. Another larger-than-life figure was Col. E. Brooke Lee, who for years reigned in the county as the Democratic Party boss. More than any individual, he is credited with founding modern-day Montgomery County. Returning from World War I, he saw that growth from the nation's capital was inevitable and pushed for the creation of unique agencies that would help guide that growth. After leaving his ancestral home in Silver Spring, "the Colonel" established a prize-winning herd of polled Hereford cattle at his up-county farm on Sweepstakes Road near Woodsfield. The farm has been developed since. (Author photograph.)

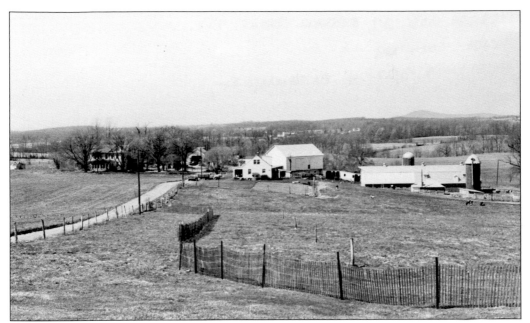

KING FARM, RIDGE ROAD, CEDAR GROVE. One of the world's leading Holstein dairy operations was conducted by the King family at King's Valley near Damascus. Under the guidance of Lesley King and his children, Kingstead Farm became a leader in the Maryland and Virginia Milk Producers Cooperative. The farm shown was the old Hilton Farm. (Author photograph.)

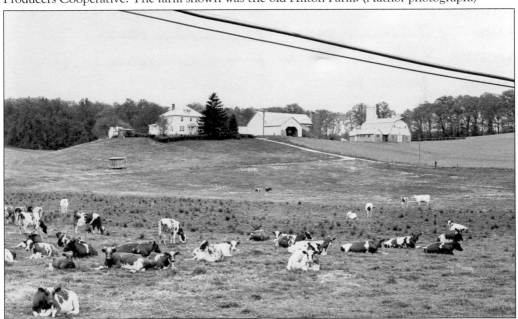

LINTHICUM FARM, OLD BALTIMORE ROAD, BOYDS. Known as Seneca Ayr Farm due to its location on Little Seneca Creek, this is the longtime home of the Linthicum family. Operated in recent decades as a dairy featuring Ayrshire cattle, it is remarkable that it is just now being developed. Jay Chadwick, who sold nearby land for Black Hill Regional Park, replied "cheap land" when asked how he came to settle in that area. When told of Mr. Chadwick's comment as his farm was being developed, Mr. Linthicum dryly replied, "it ain't cheap any more." (Author photograph.)

STONE BARN, SENECA. Built of red Seneca sandstone in the early 19th century, this fortress-like structure was designed in the Greek Revival Temple form. It served as a testimonial to the quality and strength of Seneca sandstone when it was being considered for use in the Smithsonian Castle. Ironically the barn was destroyed shortly after a group from the Smithsonian toured the area in the 1970s. (Author photograph.)

TRUNDLE BARN, DICKERSON. Also built of Seneca sandstone about 1830, this building withstood the onslaught of wartime as it reportedly sheltered Confederate sharpshooters who covered Jeb Stuart's daring escape across the river at nearby White's Ford. Stewart boldly rode through Pennsylvania and Maryland, even stopping to attend a ball in his honor at Urbana. Leaving Hyattstown at daybreak, his troops raced along Old Hundred Road practically under the nose of a Union signal station on top of Sugarloaf Mountain. Using a little-known road through the woods that was shown to them by local scout Maj. Benjamin White, a member of Stuart's staff, they were able to reenter Virginia unscathed. (Author photograph.)

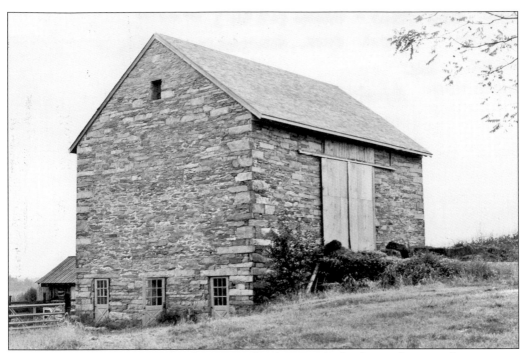

FAR VIEW BARN, BROOKEVILLE. This outstanding barn was built of stone that came from a quarry along the nearby Hawlings River. Situated off of New Hampshire Avenue—the Old Bladensburg Road—it was the home of William P. Bundy in the 1950s. (Author photograph.)

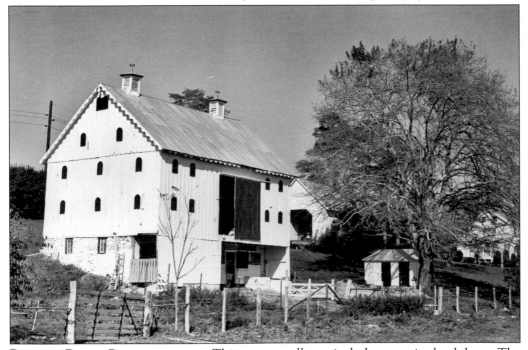

BECRAFT BARN, CLAGGETTSVILLE. This was a small, particularly attractive bank barn. The farm was the home of the Becraft family for many generations. The farm was located in the far northeastern corner of the county near the Frederick County line. (Author photograph.)

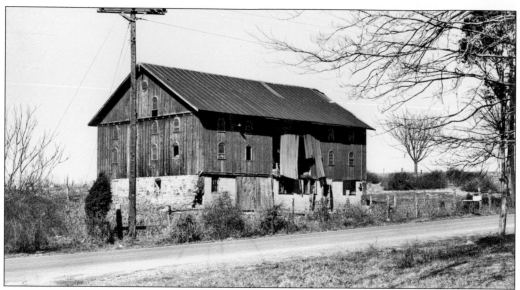

RICHTER-KING BARN, ROUTE 118, GERMANTOWN. Formerly located near the present-day entrance to South Germantown Park on Route 118 near Riffleford Road, this was a typical barn evolved from the German style. The Richter family was one of several who came from Germany, hence the name give to the surrounding community. Known for their thrift and hard work, it was sometimes said that their barns were more elaborate than their houses. Until recently this was part of the dairy farm of Herbert King. His daughter, Jean King-Phillips, continues to operate a well-known farm market on Schaeffer Road nearby. (Author photograph.)

OAK RIDGE BARN, DICKERSON. Barns were relatively simple structures despite their size, as they consisted of a number of vertical poles pinned together with wooden pegs, sometimes called treenails. (Author photograph.)

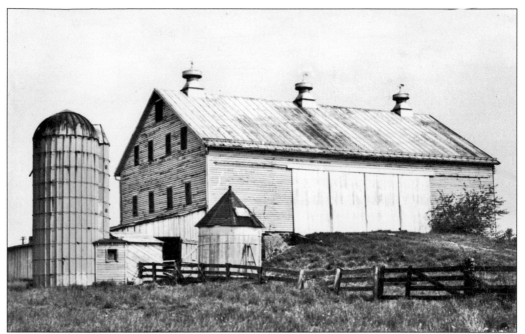

DAVIS FARM, OLD GEORGETOWN ROAD, BETHESDA. The model farm of Washington real-estate magnate Floyd Davis, this farm was adjacent to Walter Johnson High School near Montgomery Mall. It was unusual that it remained in splendid isolation long after surrounding lands had been developed. It is currently being developed as part of the upscale Rock Spring development. (Author photograph.)

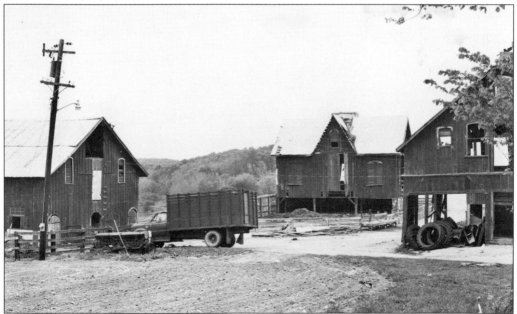

BONNIE BRAE BARNS AT BOYDS. "Colonel" James Boyd was a railroad contractor for the Metropolitan Branch when it was constructed in the county in the 1870s. Seeing an opportunity in an area where little had existed previously, he established a model dairy farm here and was one of the first to ship milk to Washington. (Author photograph.)

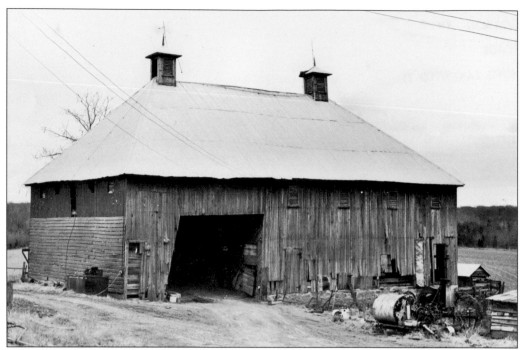

WARD BROTHERS BARN AT TRAVILAH. Constructed by Charles and Ira Ward in the 1940s using old-fashioned methods, this unusual barn is situated at their Mount Prospect farm, which had been established by Moses Montgomery in the early 20th century. (Author photograph.)

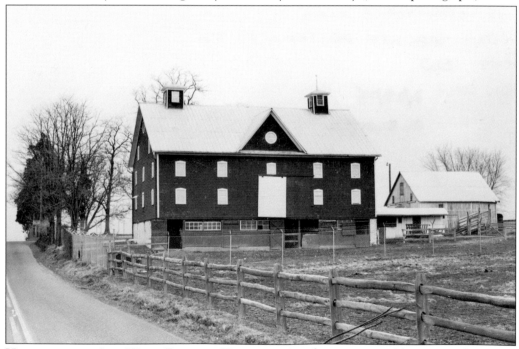

HARRISON AND ADA WARD BARN AT TRAVILAH. Another exceptional barn is on the nearby farm owned by Harrison and Ada Ward, grandparents of Charles and Ira. This farm was purchased by the Wards in the 1880s. (Author photograph.)

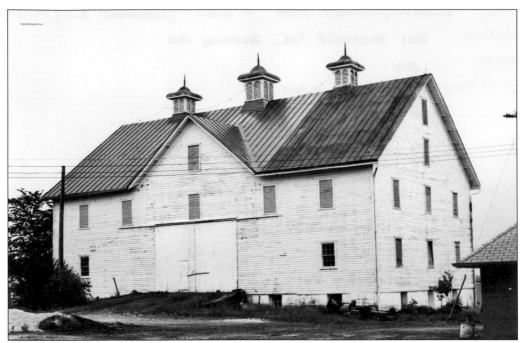

LYDDANE-BRADLEY BARN, ROCKVILLE PIKE, ROCKVILLE. This is one of the most impressive barns in the county. This structure features a row of cupolas that are functional as well as decorative; as green hay can ignite and has caused many barns to burn, the cupolas allow the hay to dry. (Author photograph.)

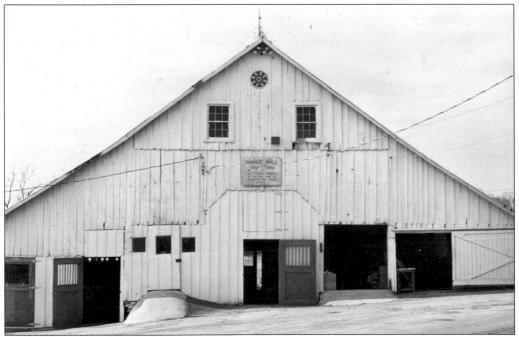

SUMMIT HALL BARN, GAITHERSBURG. This unusual barn is located on the former Summit Hall turf farm, which was acquired by the City of Gaithersburg for a multi-use park along Route 355. (Author photograph.)

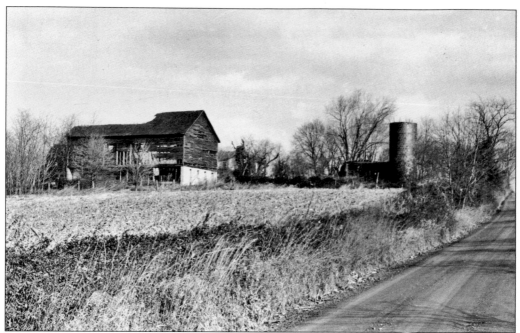

GUDE FARM, NEEDWOOD ROAD, DERWOOD. This farm was originally owned by the Robertson family, who lived at nearby Needwood Mansion. In the 20th century, it was owned by Judson Gude, son of a well-known nurseryman, whose other son, Gilbert, promoted conservation causes as a U.S. Congressman. (Author photograph.)

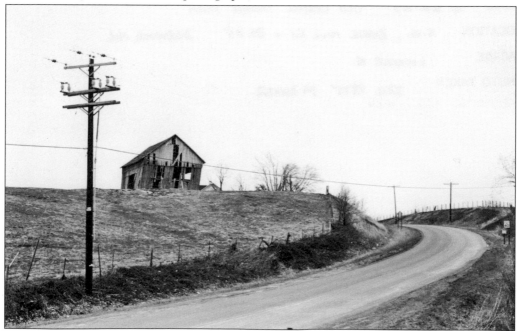

CASHELL TENANT FARM, DERWOOD. This farm is situated on a hill overlooking the intersection of Bowie Mill and Muncaster Mill Roads. This and many similar structures have disappeared in recent decades. Some have been replaced by large single-family homes, sometimes referred to as "pasture palaces." (Author photograph.)

Seven

COUNTRY TO CITY ROADS

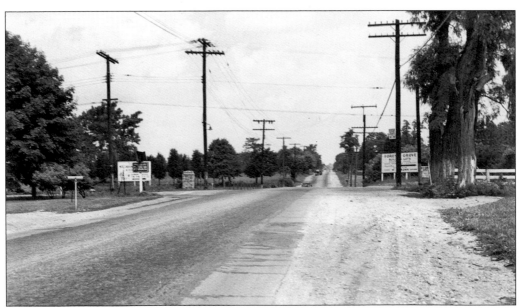

GEORGIA AVENUE AT FOREST GLEN ROAD. There was still a lot of open land north of Silver Spring when this photograph was taken in 1942. This would change rapidly, as the Wheaton area would bear the brunt of development over the next several decades. Note the sign on the right in this photograph announcing a coming subdivision. The sign on the left points the way to the historic St. John's Catholic Church, home of Bishop John Carroll in the 18th century. A new church was eventually built on Georgia Avenue, where Union general George Washington Getty had settled after the Civil War. Once known as Leesboro, Wheaton took its name from an associate of Getty's, Gen. Frank Wheaton, who was credited with saving the day during Jubal Early's raid on Washington in 1864. Another Union veteran, Postmaster George Plyer, reportedly suggested the name change for this community. (MNCPPC Archives.)

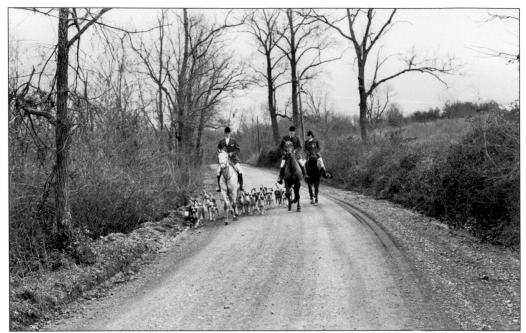

WHITE GROUNDS ROAD, BOYDS. The author encountered the Potomac Hunt one mid-week afternoon during the fall of 1973. At the time, many of the roads in the up-county were unpaved. Because of the fear that the gravel contained asbestos, most of the dirt and gravel roads were sealed with asphalt. (Author photograph.)

MARTINSBURG ROAD, DICKERSON. Dubbed "politicians' pig paths," these one-lane concrete roads were reportedly signs of influential landowners who were able to get good roads to their farms. Matthew's dairy farm was the scene of country, western, and bluegrass concerts in the post–World War II era. (Author photograph.)

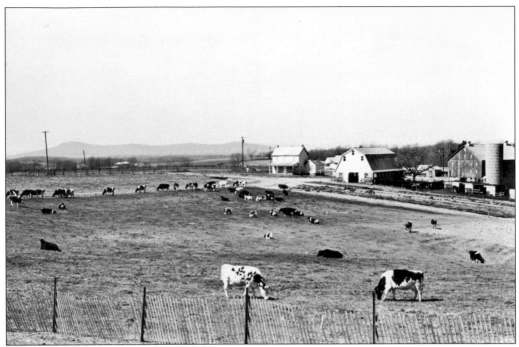

KING'S VALLEY ROAD, WEST, DAMASCUS. Sugarloaf Mountain formed a beautiful background for William Watkin's dairy farm in the 1970s. The vista at Ridge Road was too good to last, as the farm has been developed recently, and now only a few can see the view! (Author photograph.)

KING'S VALLEY ROAD, EAST, DAMASCUS. This view looks southeast over miles of open land in 1974. The area to the left is now Damascus Regional Park, and the area beyond is now a sea of houses. (Author photograph.)

PRATHERTOWN, NEAR MONTGOMERY VILLAGE. One of a number of "kinship communities" formed by free blacks and freed slaves in the post–Civil War period, roads in these areas remained substandard until new housing developments arrived. (Author photograph.)

OAKLYN DRIVE, POTOMAC. Now the site of the upscale Avenel community, in 1974, this was still a dirt road leading to an old black community where locally famous horseman Johnny Jackson lived. (Author photograph.)

SKYLARK ROAD, CEDAR GROVE. Located near its intersection with Route 27, or Ridge Road, this property was farmed by the Johnson family and is currently being developed as Arora Hills. (Author photograph.)

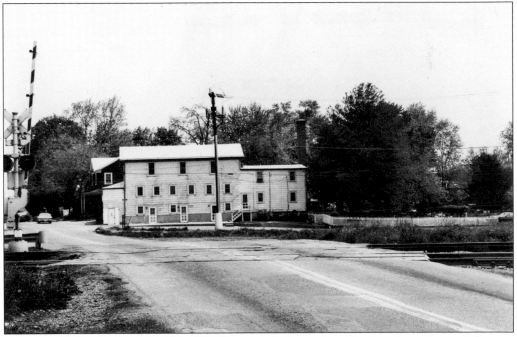

REDLAND ROAD, DERWOOD. This 1974 photograph shows the old railroad crossing and the post office in the background. Basil Mobley's cows were still grazing nearby before the arrival of the Shady Grove Metro. (Author photograph.)

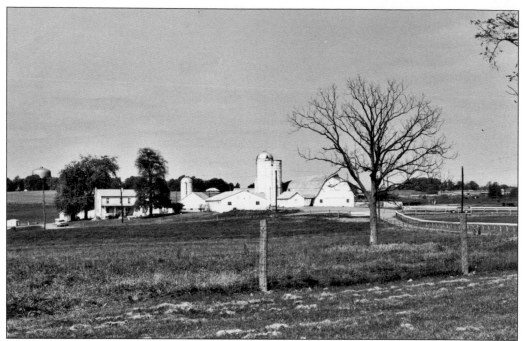

FIELDS ROAD, ROCKVILLE. Not so long ago, traffic passed by these barns at Irvington Farm in what was considered Gaithersburg at that time. Annexed by the city of Rockville, it has been heavily developed under the King Farm name in order to take advantage of the nearby transit station. (Author photograph.)

SHADY GROVE ROAD, ROCKBURG. Looking southwest from Monument View Hill before I-370 became a Metro access road, Shady Grove is in the foreground and the King Farm in the distant background. (Author photograph.)

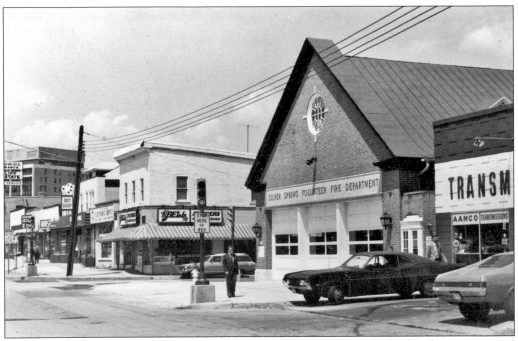

GEORGIA AVENUE, SILVER SPRING. Back down-county, some familiar landmarks remain amid booming Silver Spring. The firehouse shown here was originally the National Guard Armory, preceding the "new" armory, which was demolished. (Author photograph.)

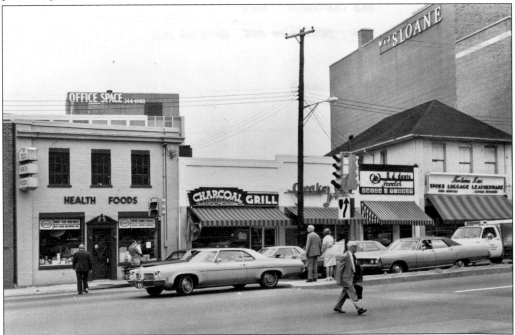

WISCONSIN AVENUE, BETHESDA. As traffic has increased dramatically in recent years, crossing the roadway can be hazardous to your health. While Bethesda, Silver Spring, and Rockville have become urbanized, other areas such as Germantown and Clarksburg are not far behind. (Author photograph.)

I-495 AT FOREST GLEN. Affectionately know as the Beltway, this photograph taken 30 years ago almost makes one nostalgic for the good old days when traffic was this light. The cars shown here are headed west toward the "Rock Creek Roller Coaster," the section of highway that twists and turns to avoid Rock Creek Park. (Montgomery County Historical Society photograph.)

MARTIN'S DAIRY, OLNEY. Located along Georgia Avenue south of Olney, the former dairy became one of several stopping points for suburbanites out for a drive in the country. The only building remaining here today is the 19th-century Higgins Tavern shown in the background. (Author photograph.)

BONFIELD'S GARAGE, BETHESDA.
Some roadside attractions have been preserved, even in heavily developed areas. Wally Bonfield, an eccentric Englishman, delighted passersby with his signs advertising Moog Balls and other obscure automotive parts. (Author photograph.)

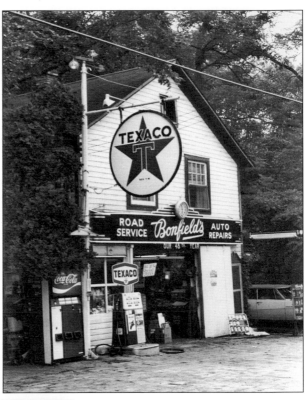

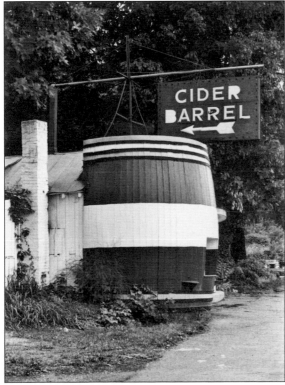

CIDER BARREL, GERMANTOWN.
Located along Route 355 near Middlebrook, this was a familiar up-county landmark and a required stop each fall for fresh apple cider. Once located amidst old tourist cabins and trailer parks, the area has been totally transformed by recent development. (Author photograph.)

ROUTE 28 NEAR CATTAIL ROAD, POOLESVILLE. This view looks southwest over miles of open countryside. It's still possible for city dwellers to take a ride through rural upper Montgomery County. (Author photograph.)

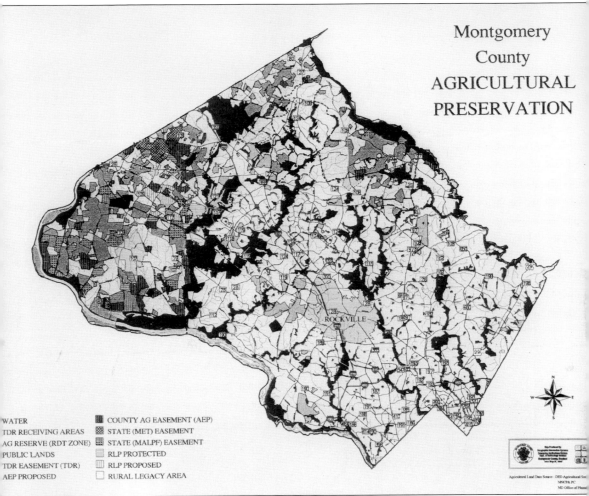

Montgomery County AGRICULTURAL PRESERVATION

ROCKVILLE

WATER

TDR RECEIVING AREAS

AG RESERVE (RDT ZONE)

PUBLIC LANDS

TDR EASEMENT (TDR)

AEP PROPOSED

COUNTY AG EASEMENT (AEP)

STATE (MET) EASEMENT

STATE (MALPF) EASEMENT

RLP PROTECTED

RLP PROPOSED

RURAL LEGACY AREA

MAP OF THE AGRICULTURAL RESERVE. Despite the steady loss of farmland over the years, more than one-third of Montgomery County is still in agricultural use. With over 500 farms in operation, the county has been cited as having the most successful agricultural program in the country. (Jeremy Criss.)

MICHAEL DWYER, BOWIE HILL FARM, WHEATON, MARYLAND. This 1961 photograph is of the author as a young man recording the now-demolished home of Allen Bowie Jr., also known as the Hermitage.